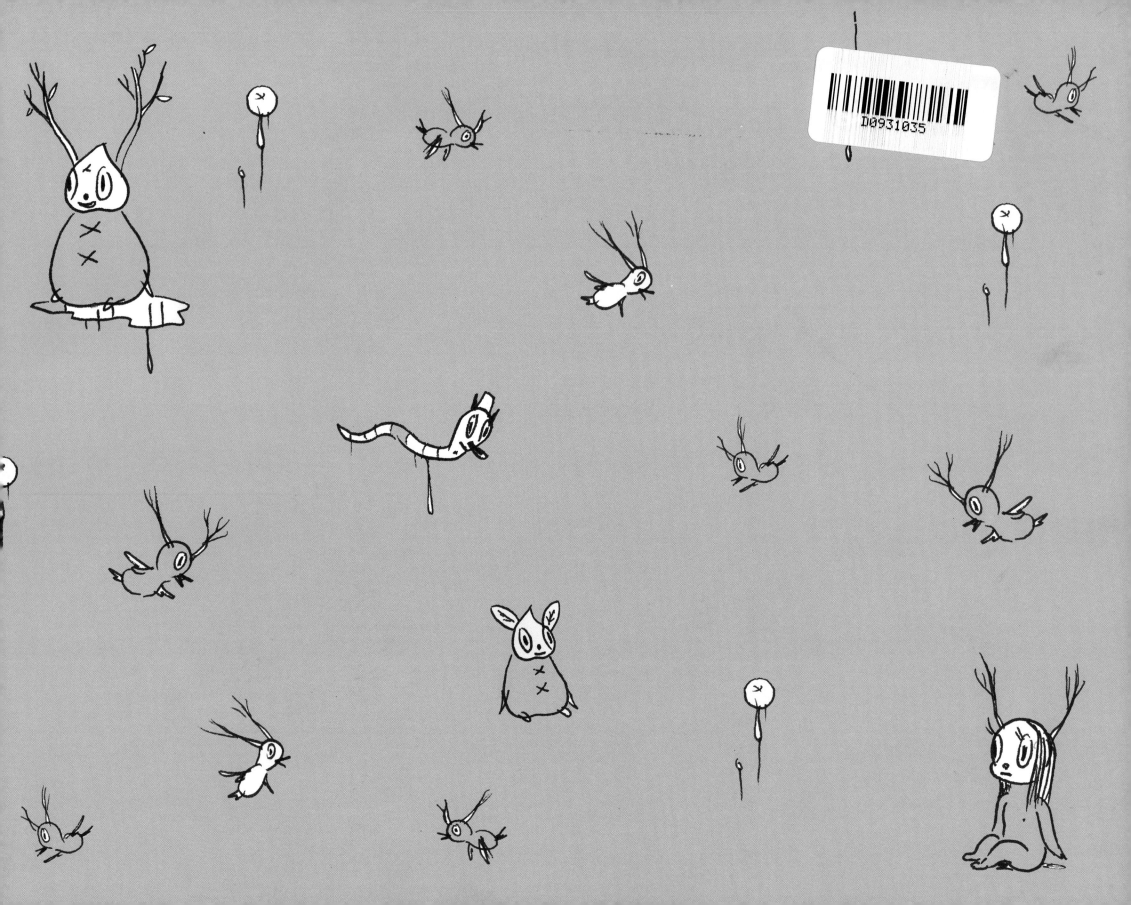

4 May 06

After my lecture in OSLO,
a mother came up
to me who brought
her ~~dau~~ 12 year old
daughter to my lecture.
The daughter turned to her
mom and said
Mr. Baseman
really does love
women.

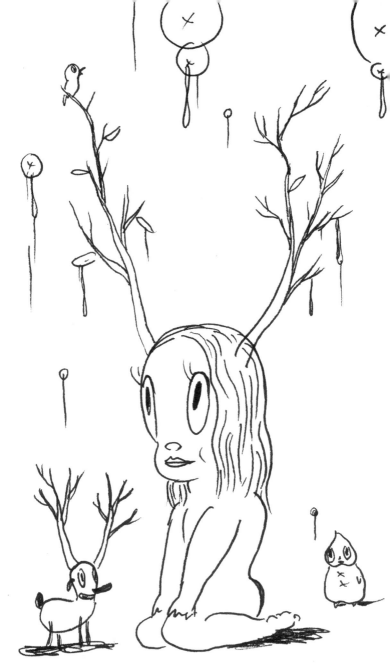

~~another~~ one more dying wish
~~my dying wish~~

I wish I could remember you.

I think I'm wounded.
Thirteen shots to the head

Dirty girls

Another fine mess
Another day of lost memories
I cut myself again
Things shouldn't have to be this
 difficult.

I can almost remember longing for you

~~I locked myself out of the woods~~
I killed another beautiful moment

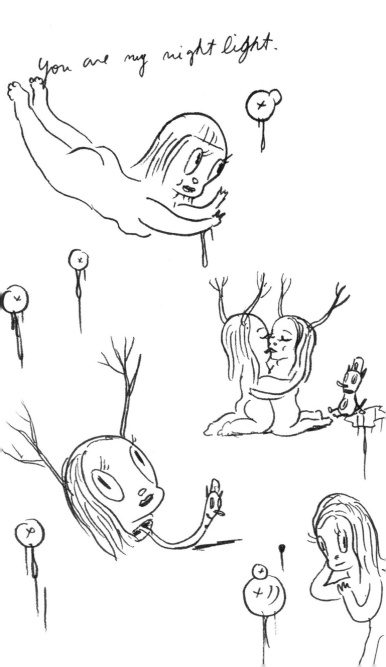

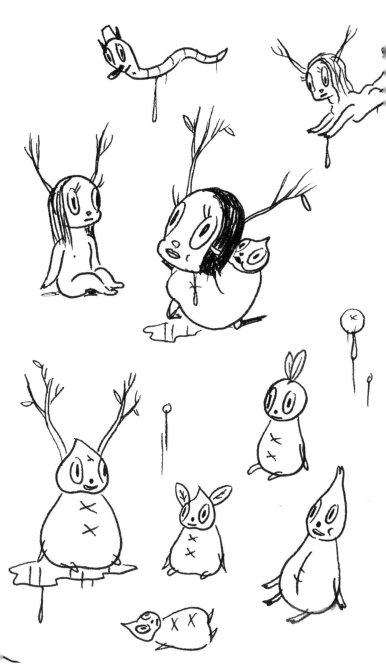

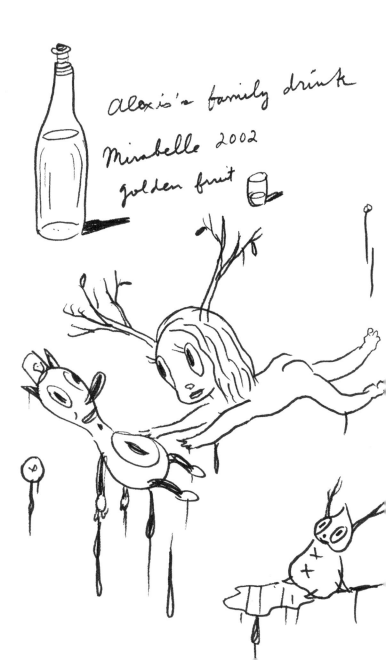

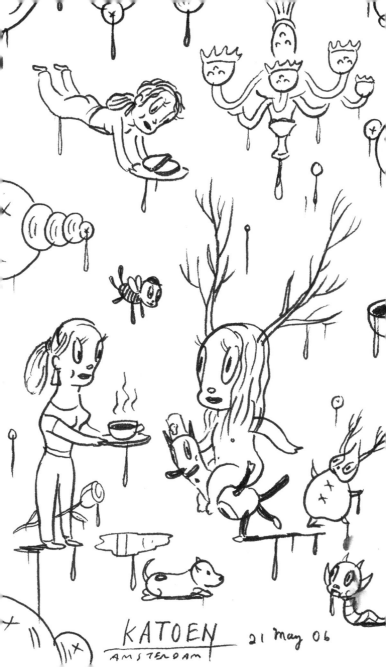

KATOEN

AMSTERDAM

21 may 06

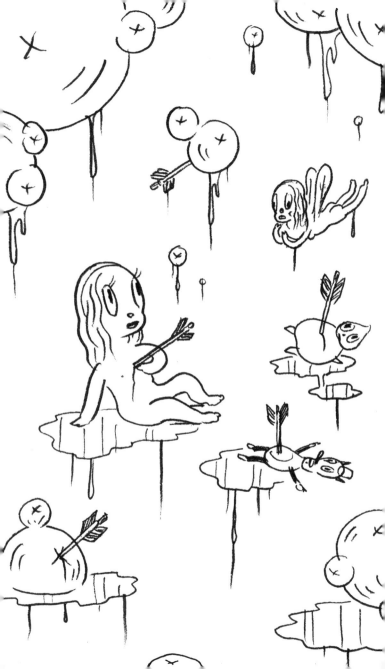

Desire is my drug.

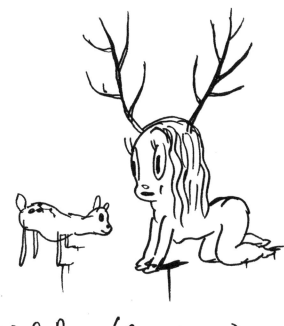

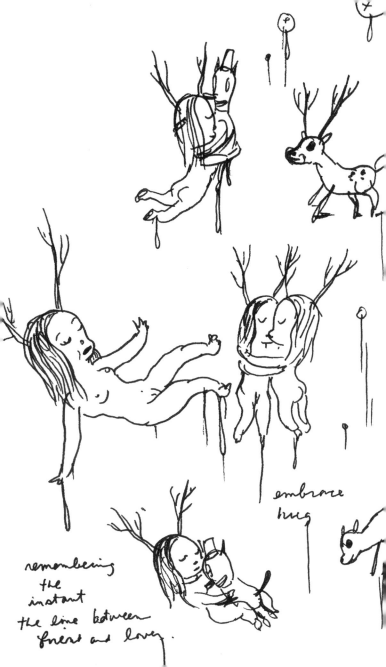

embrace
hug

remembering
the
instant
the line between
friend and lover.

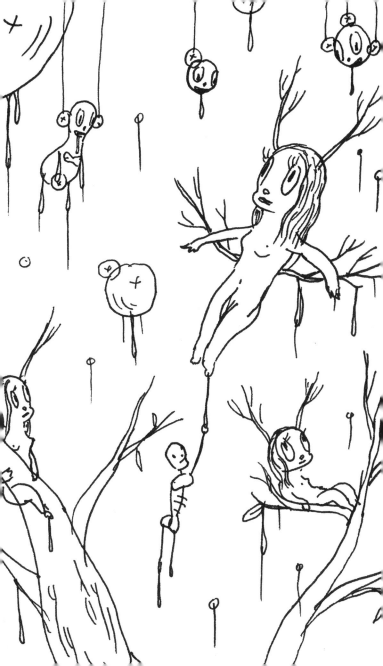

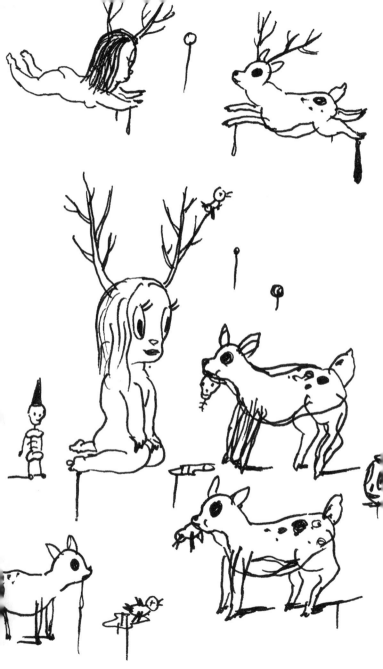

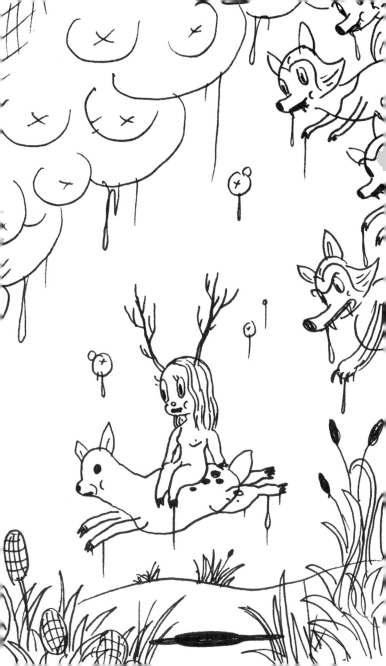

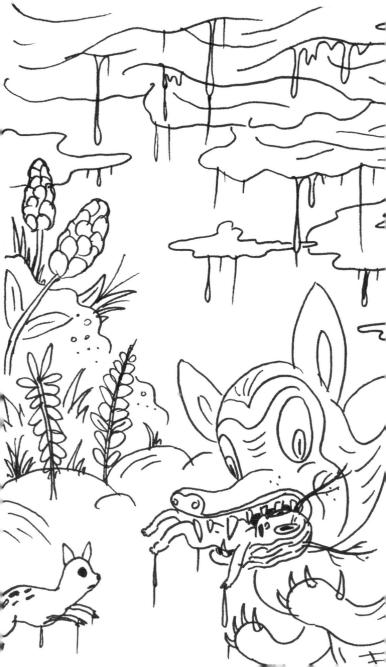

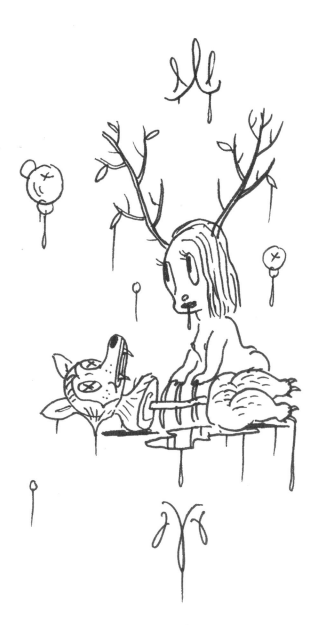

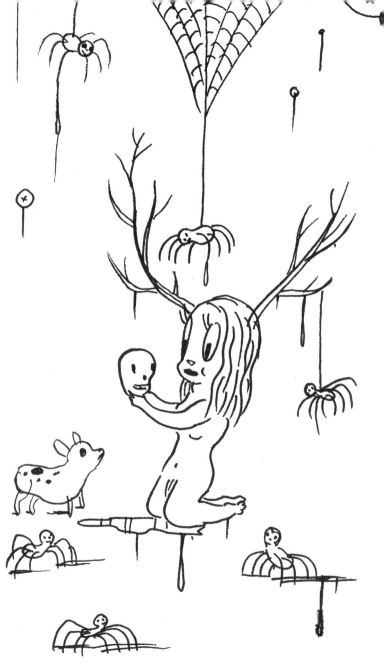

My life is more surreal
 than my art.
Everyone lives in their own
 imaginary world.
It is harder to communicate
 with them than learn a
 foreign language.

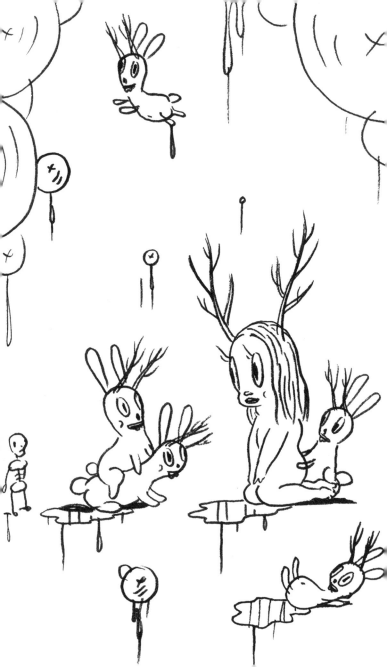

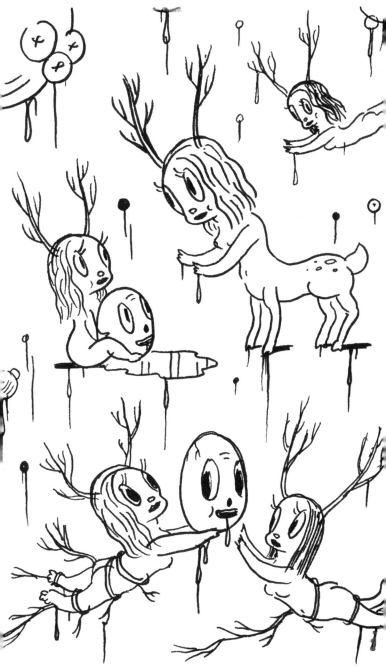

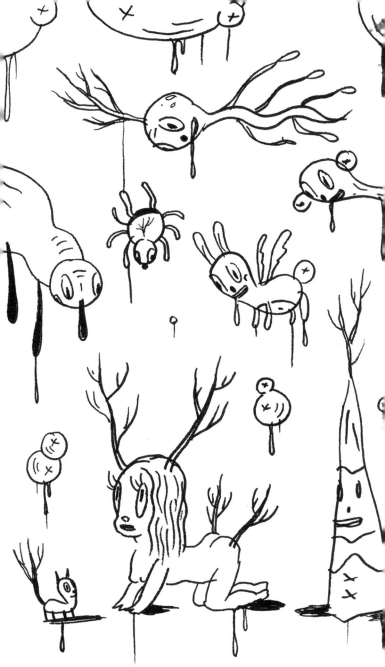

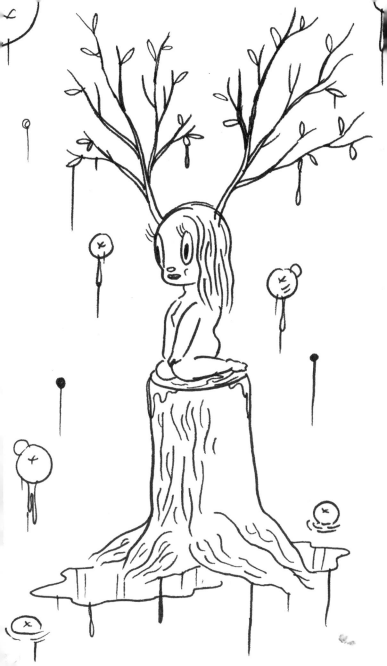

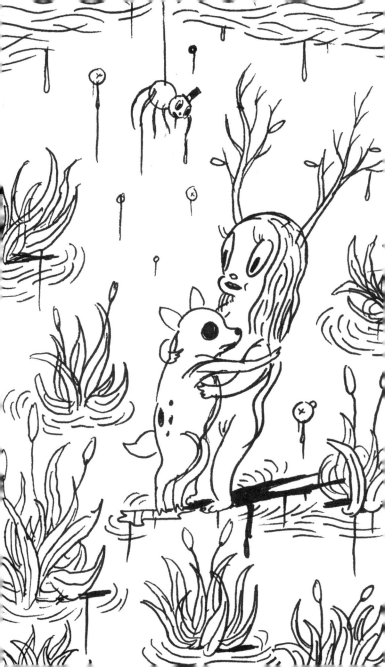

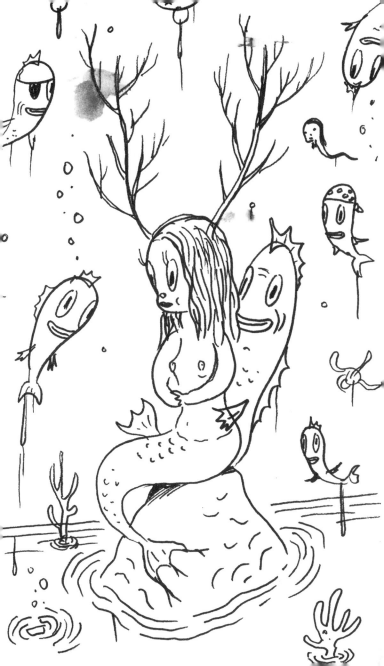

Life is bittersweet with all its years and rip~
flesh from struggles of survival.

 dreaming about eating
I've been ~~eating~~ Venison meat
 many ~~many~~
for many ~~a few~~ years.
 ~~actual seeing~~
But ~~only discovered~~ ~~wild venison~~
~~during my last trip to Europe.~~
But I only discovered her during my
recent trip to Europe.

 I ran away from home and hid
into the woods. ~~tree he~~ tripping
over a tree and ~~fo~~ hit my head
and fell unconscious. When I woke
up, I saw ~~this~~ beautiful wild
 She nursed me wi~
Deer girl ~~sniffing~~ me her tongue.

She healed my wounds with ~~my~~ tongue.
She ~~forced me on ток~~, she managed to
carry me to her nest. With her love she
nursed me to health. She healed
my wounds with her tongue.
She fed me like I was her baby.
Then proceeded to eat my heart out.
Venison girls are quite dangerous.
Be careful when you see them on
road. They are very accident p~
and tend to leap into the
middle of the road.

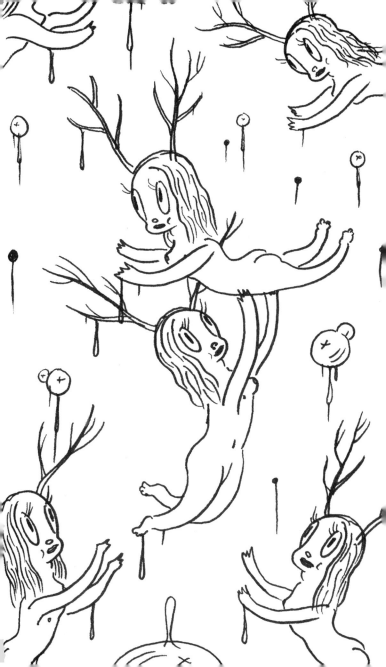

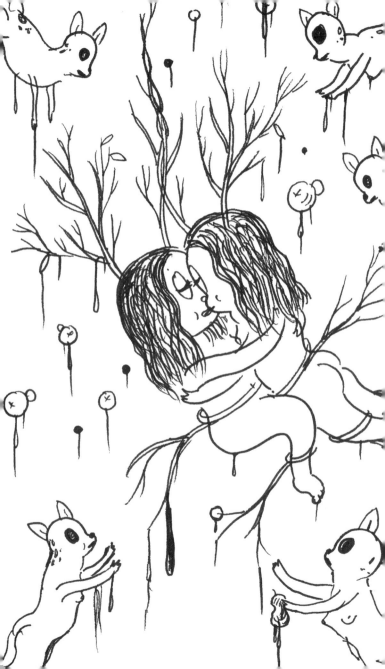

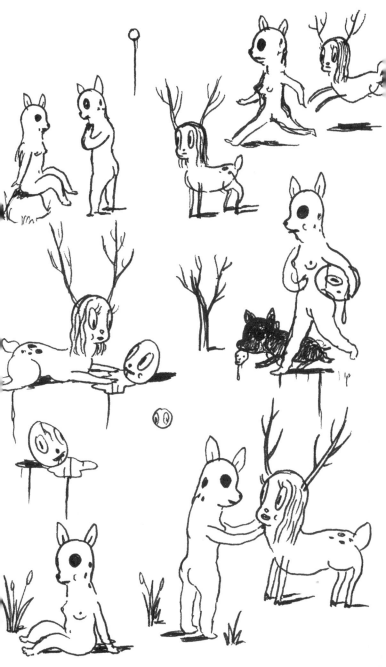

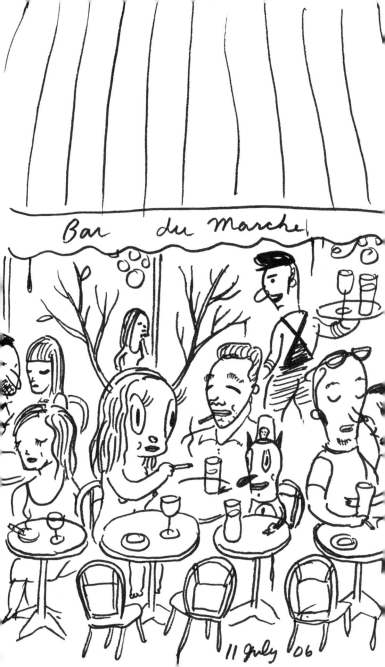

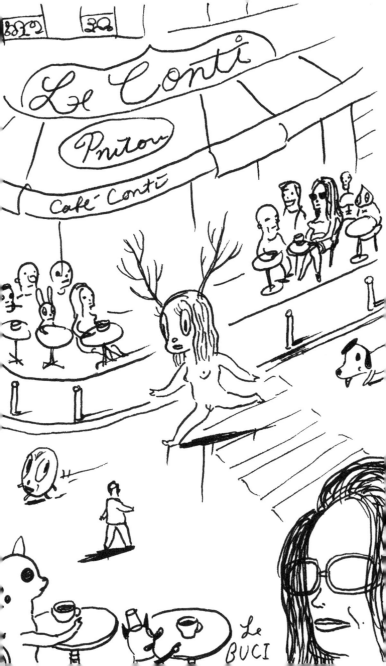

BAISE
MAN

"SEE THAT.
"THAT IS A CA
HE IS THE
DEVIL"

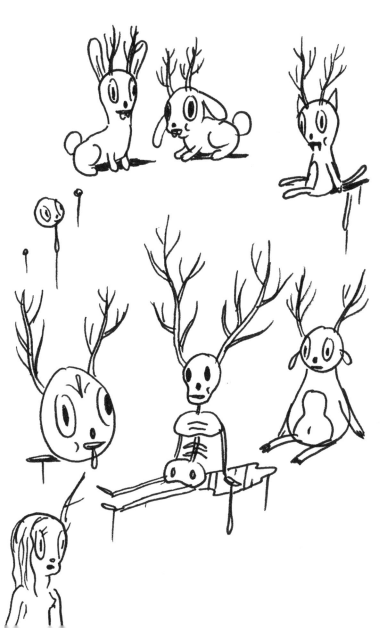

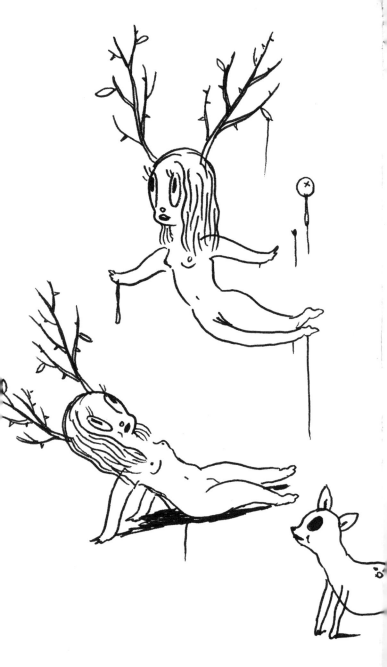

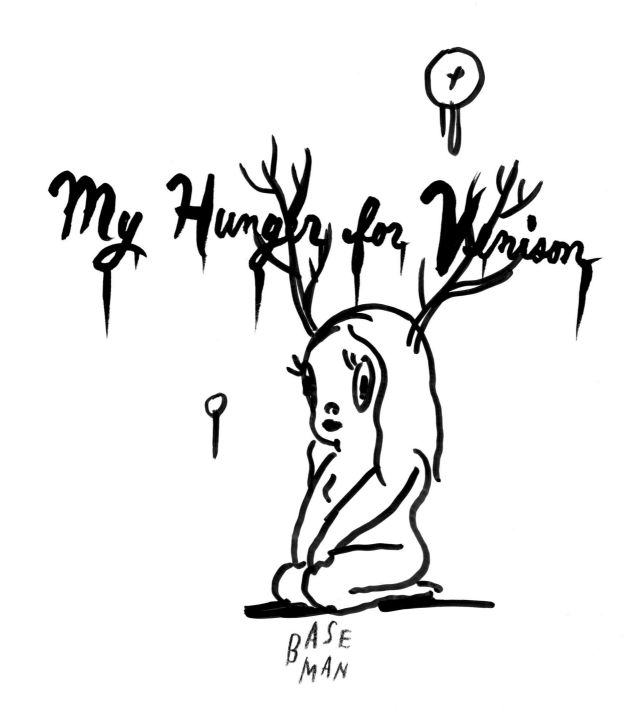

My Hunger for Venison

BASE MAN

To the ART Department @ UWEC

DISC RDER BASE MAN
2007

ISBN 978-0-9778949-3-2

First Edition

10 9 8 7 6 5 4 3 2 1

Published by Baby Tattoo Books®
Los Angeles
www.babytattoo.com

Manufactured in China

14779206

cc

INTRODUCTION

Venison

I have been dreaming about eating Venison meat. But I only discovered her during my recent trip to Europe. Not at a restaurant but running free in my head.

I was a prisoner.

I escaped and ran away this spring and hid in the woods. I ran so fast I did not look where I was going and smacked my face right into a tree limb, Bam.

I fell unconscious with my mouth all bloody. When I awoke, I found this beautiful beautiful wild deer girl up against my face, nose to nose, sniffing me. She started licking my dried blood on my lips and began healing me with her tongue.

Then she proceeded to devour me.

Nature stalks its prey. Leaps and consumes its helpless victims. Fresh kill. Poor victims of love and desire.

Was I being saved or was I the feast?
It doesn't matter.

This a true story.
Fuck truth while desire rules the earth.
Monsters destroy the innocent.
The innocent still hurt the ones they love.
Desire covers my eyes with my own fresh blood
and blinds my vision.

I am a willing sacrifice.
My naked bones lie in peace in the dirt and filth
of my imagination.
Wet dreams nourish my desire.

The pain of growth is great.
I don't care.

Hurt me you mother fucker.
Hurt me. You can't hurt me.
Take a fucking bite out of me.
The hell fury I went through won't match the pain
I will have to endure.
There is a reason I ran into the woods.
It is a cycle of life.
Life is beautiful.
Beautiful and bittersweet.

This new collection of drawings
introduces my muse Venison.

I produced most of these drawings during my stay
in Barcelona at the café Rosal.

They are not studies for future paintings but final
works of art.

During my return home to Hollywood,
I finished the body of work for this
exhibition of drawings and added four paintings
of my wild deer girl to the series.

Buen Provecho

Gary Baseman

BASE
MAN

I. VENISON'S HUNGER

ACRYLIC ON CANVAS
12 X 16

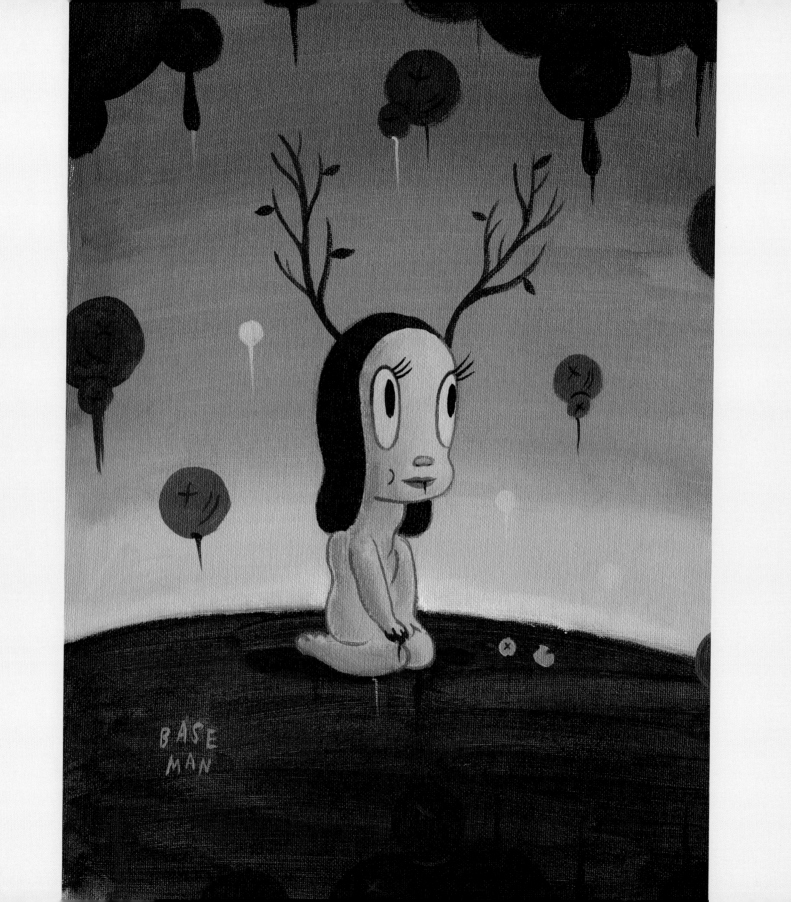

2. THE RITE OF VENISON

DRAWING

12.625 X 9.5

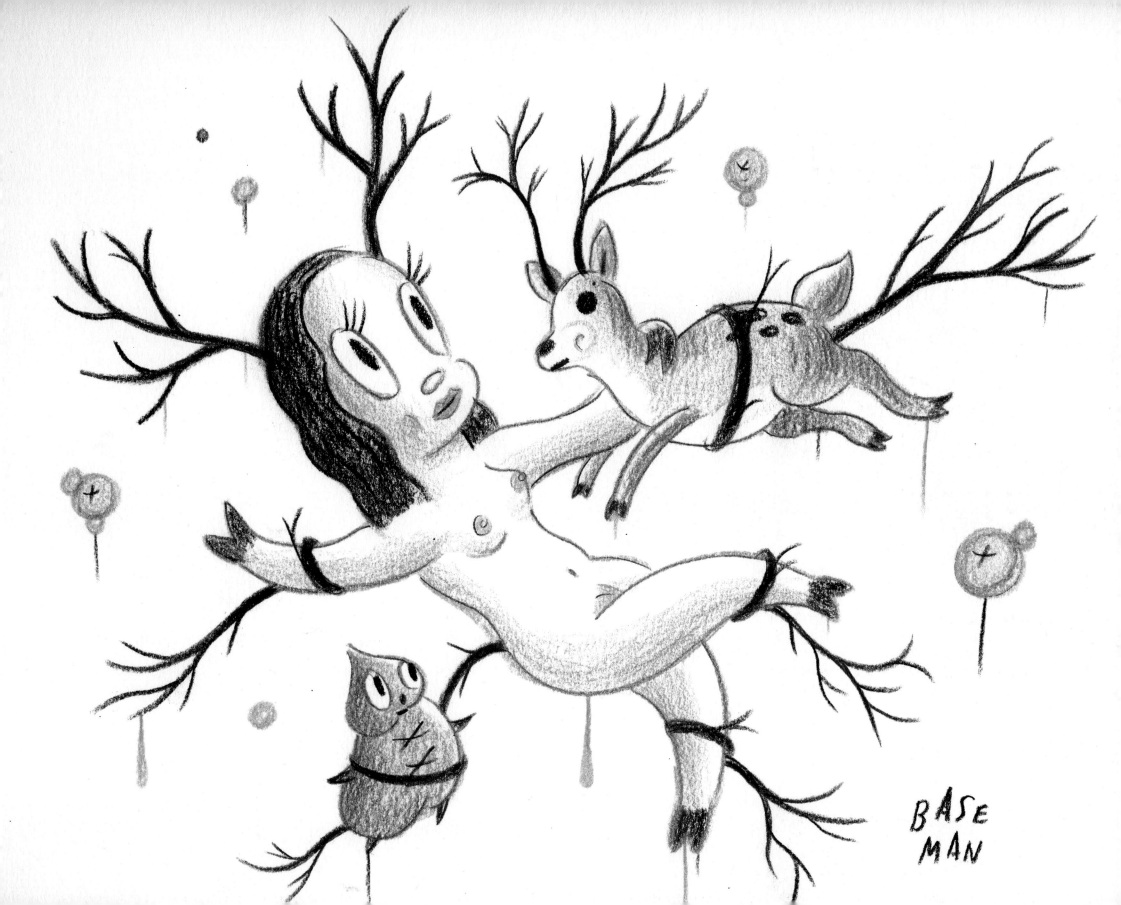

3. SEARCHING FOR LIFE

DRAWING

12.625 X 9.5

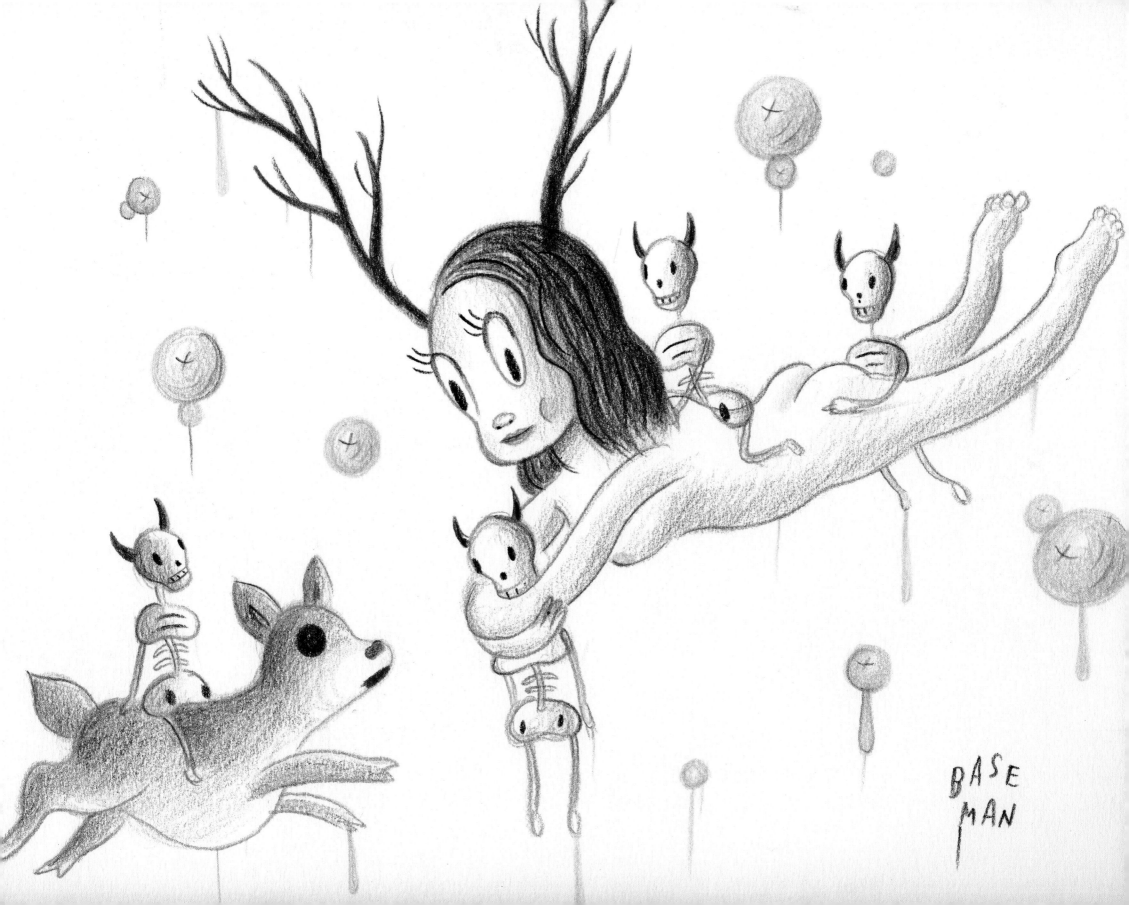

4. THE GIfT I

DRAWING

12.625 X 9.5

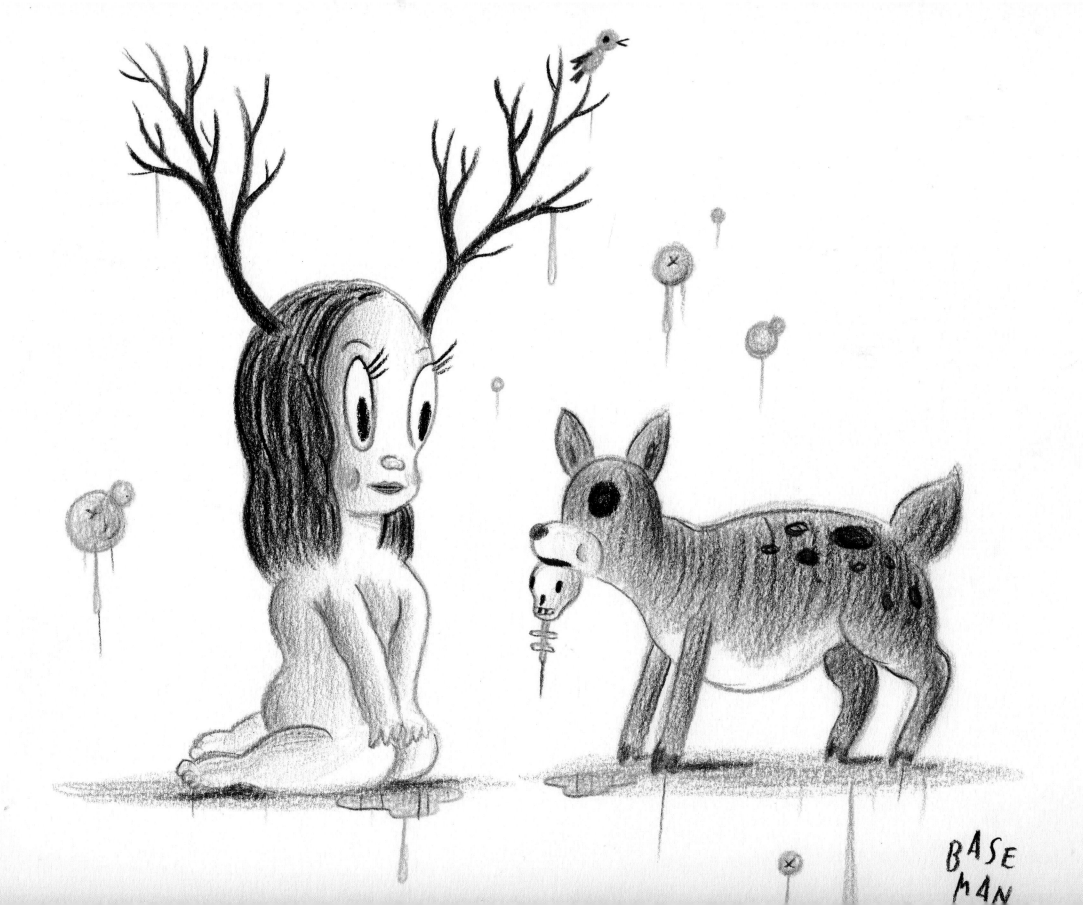

5. VENISON'S CRADLE

DRAWING

12.625 X 9.5

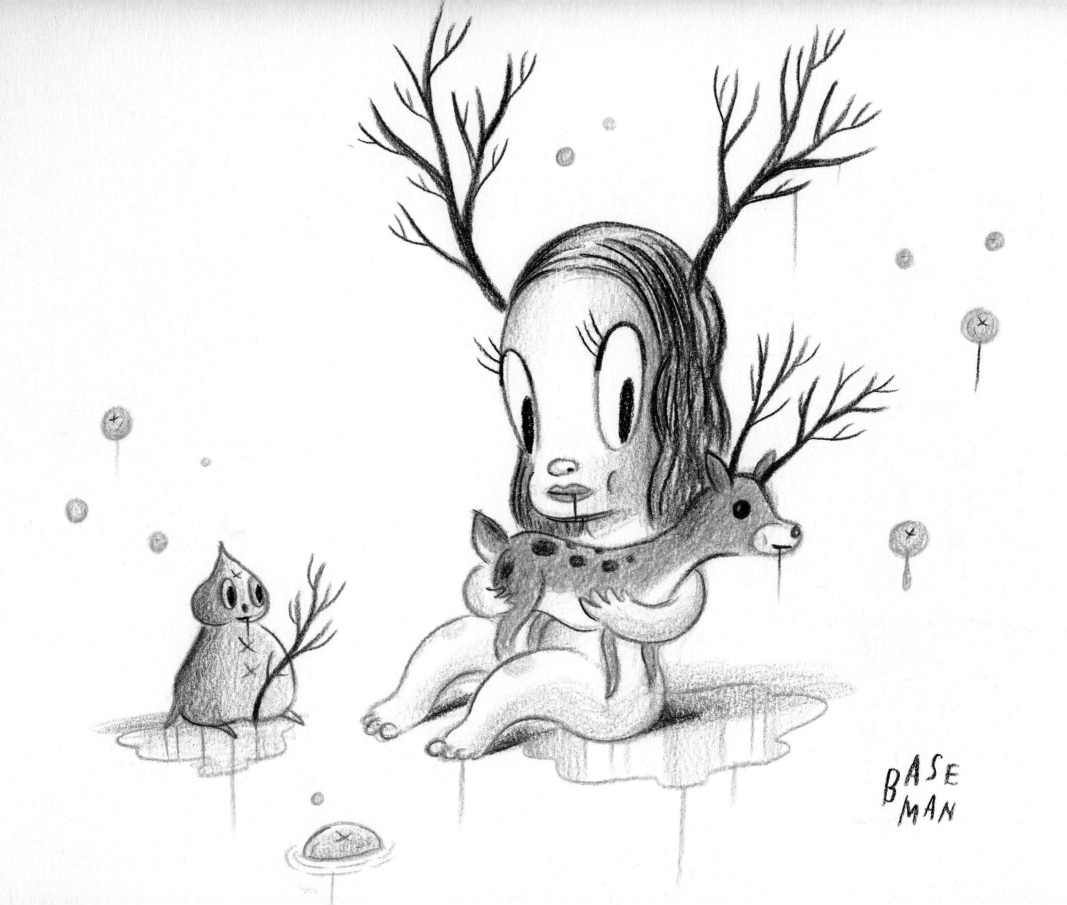

6. VENISON'S STROLL

DRAWING

12.625 X 9.5

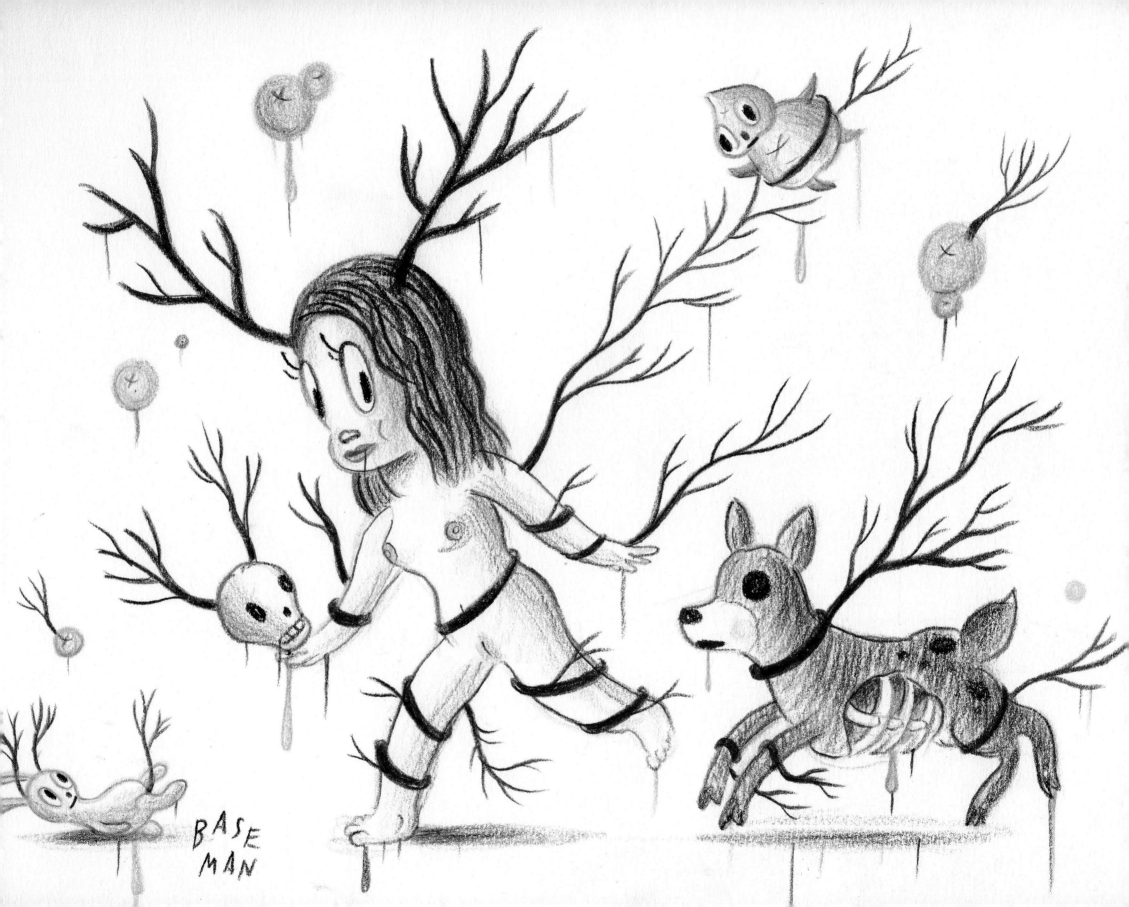

7. THE RIDE

DRAWING

12.5 X 9.5

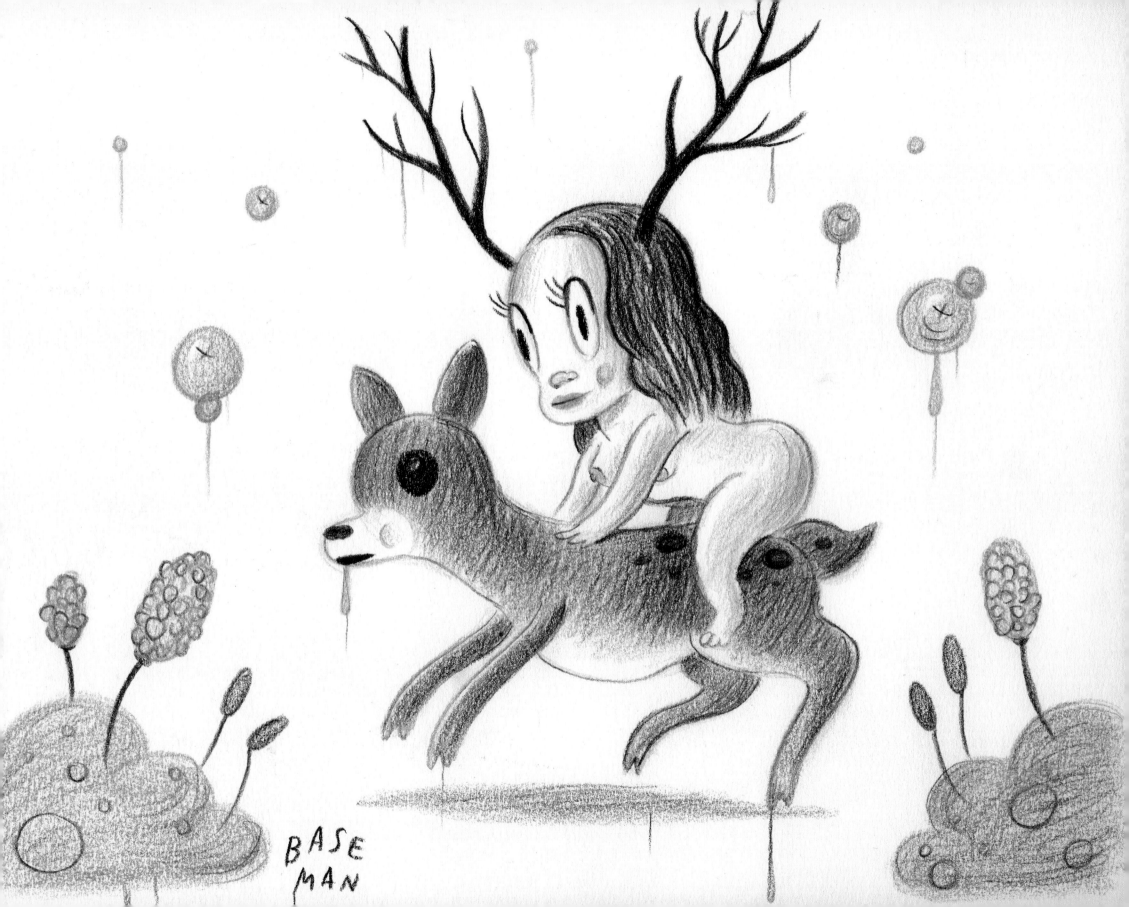

BASE
MAN

8. THE HUNT (VENISON ON ALL FOURS)

DRAWING

12.625 X 9.5

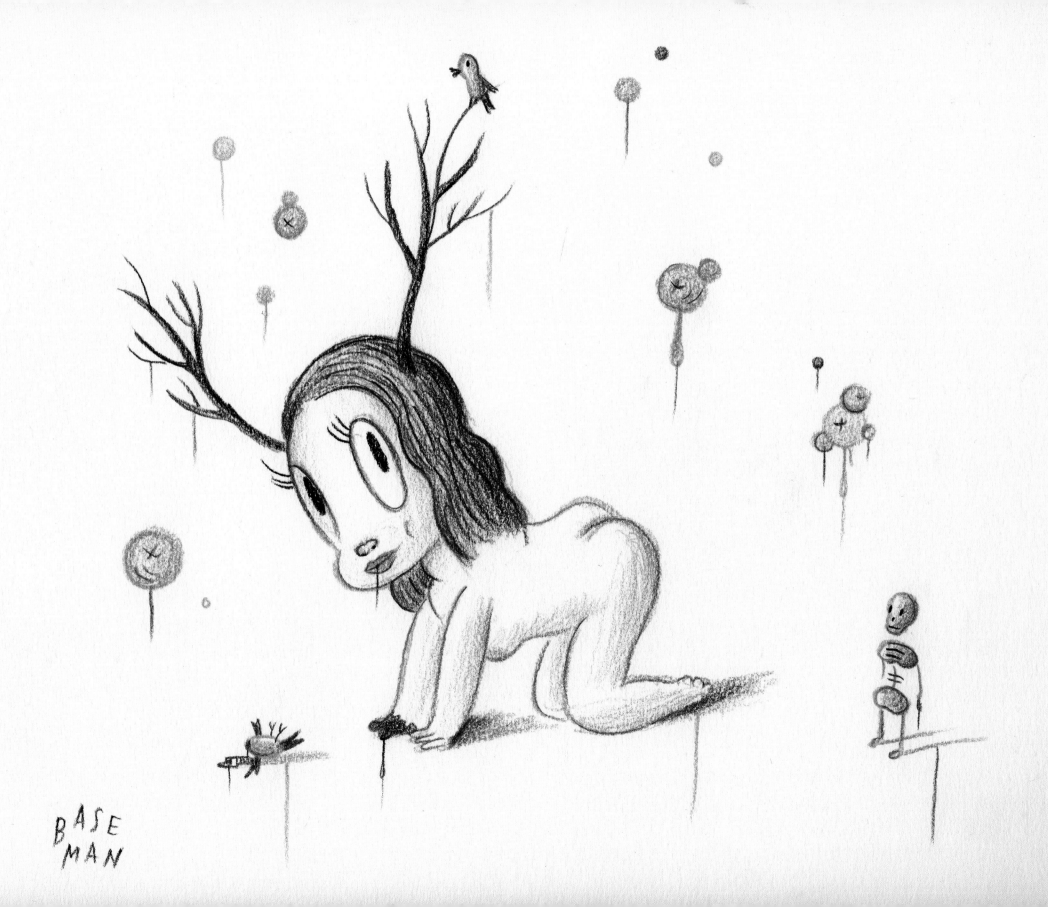

9. VENISON'S STRUCK

DRAWING

12.625 X 9.5

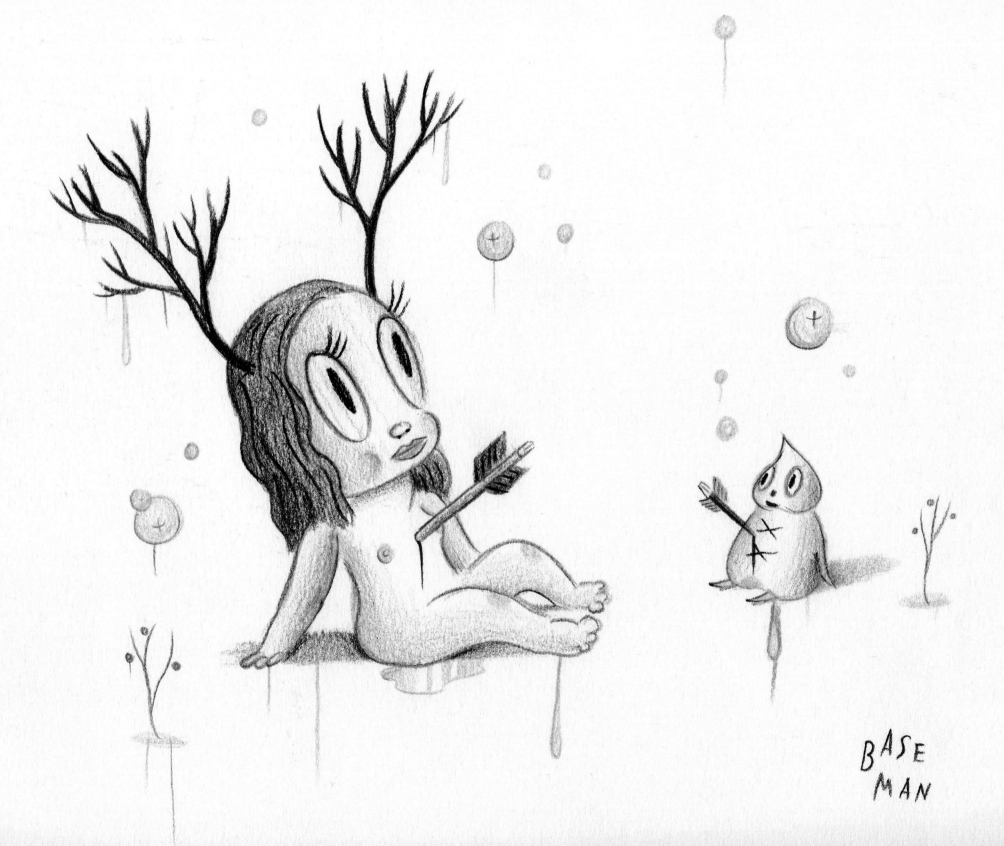

10. VENISON BOUND

DRAWING
HAND-MADE BARCELONA PAPER
7 X 9

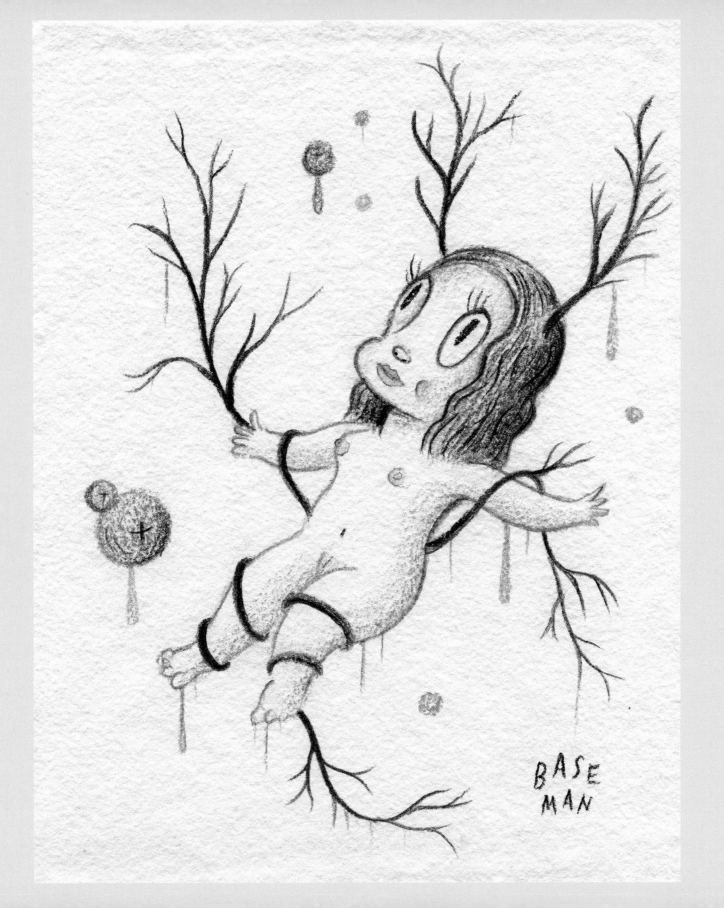

II. THREE VENISONS

DRAWING

12.625 X 9.5

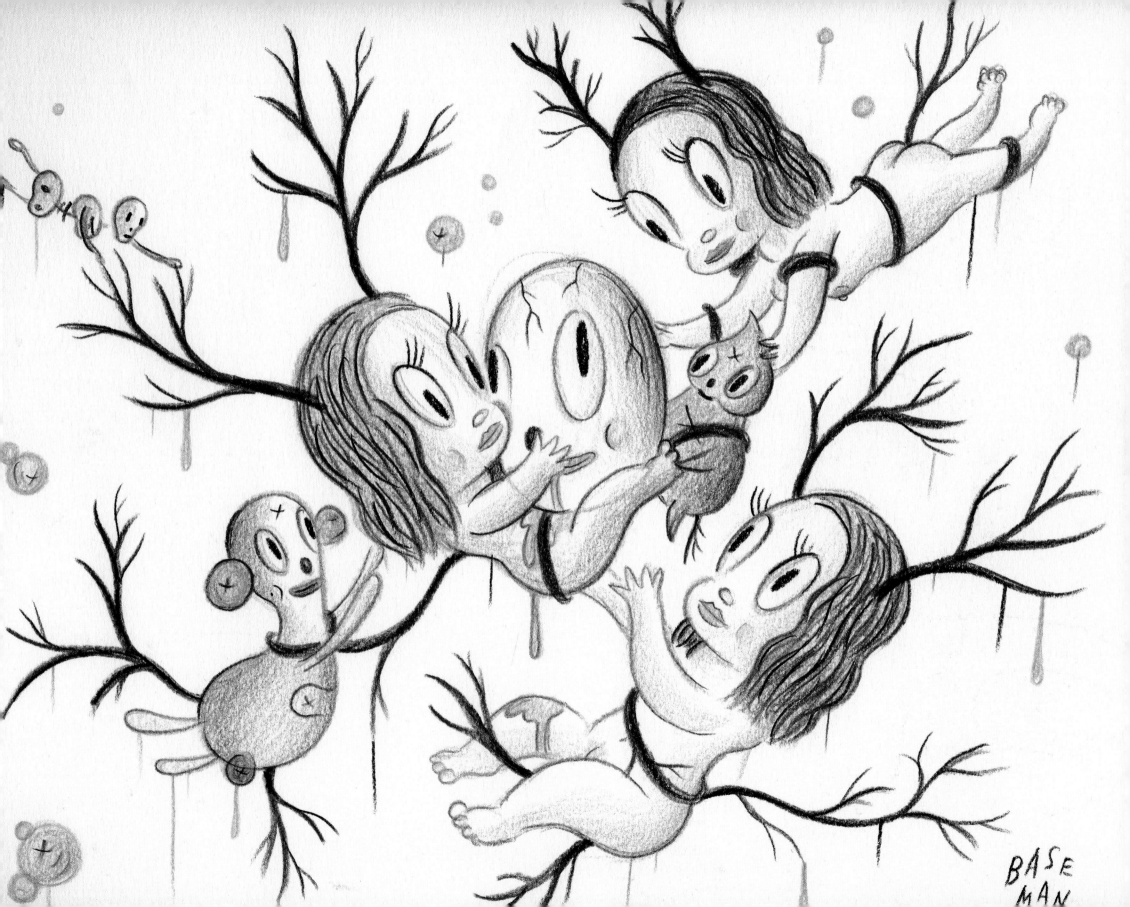

12. VENISON'S DREAM

DRAWING
HAND-MADE BARCELONA PAPER
9 X 7

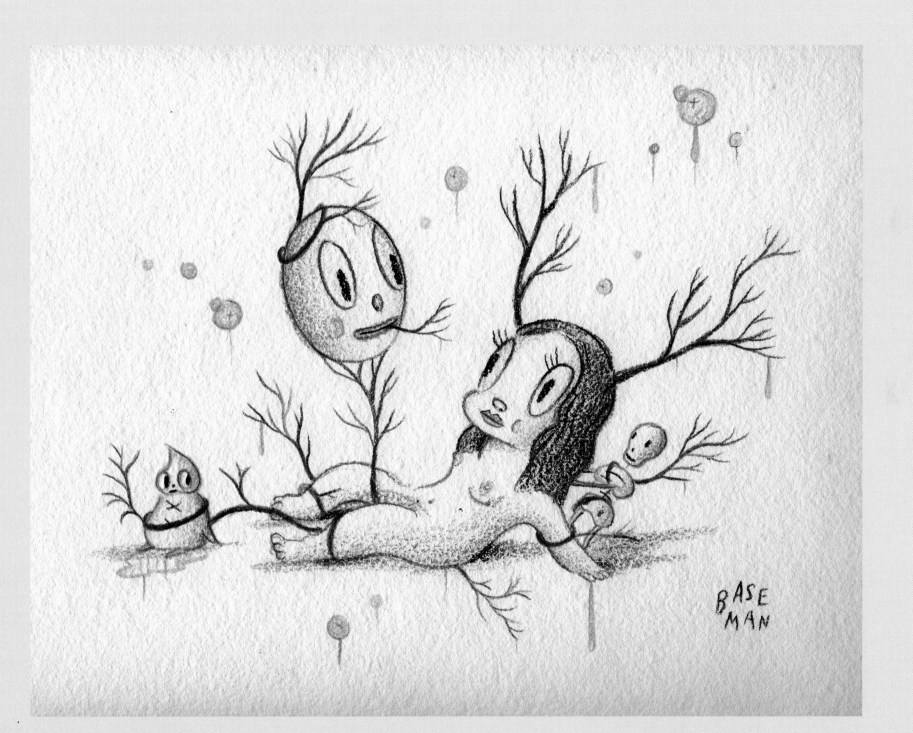

13. EGG HUNT

DRAWING

12.625 X 9.5

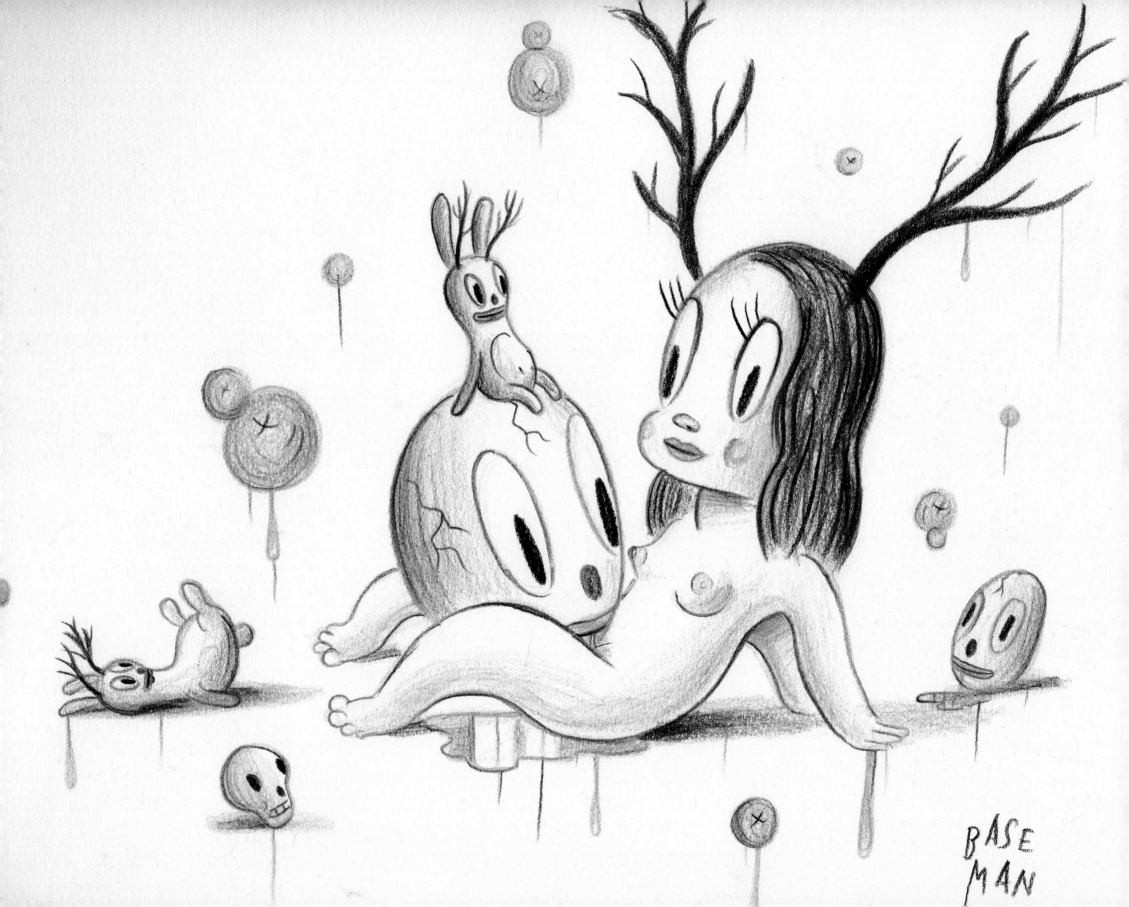

14. VENISON'S VISION

DRAWING
HAND-MADE BARCELONA PAPER
9 X 7

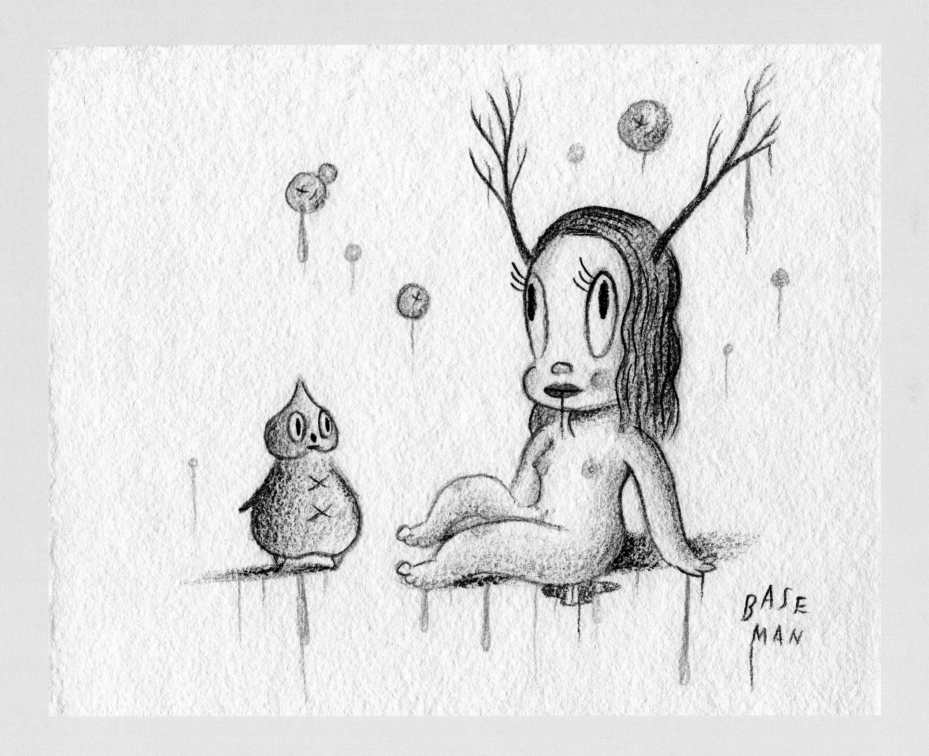

15. VENISON TWINS

DRAWING
HAND-MADE BARCELONA PAPER
12 X 9.5

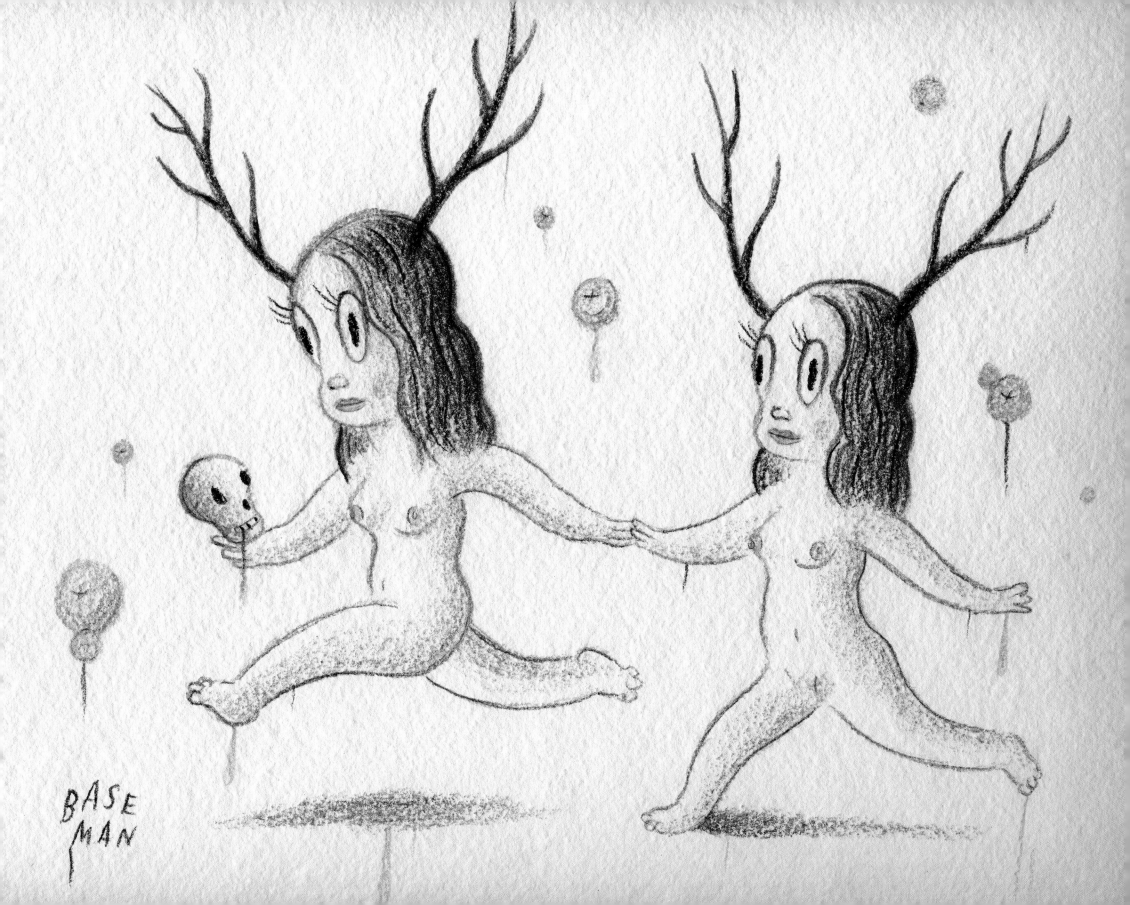

16. VENISON'S VENISON

ACRYLIC ON CANVAS
12 X 16

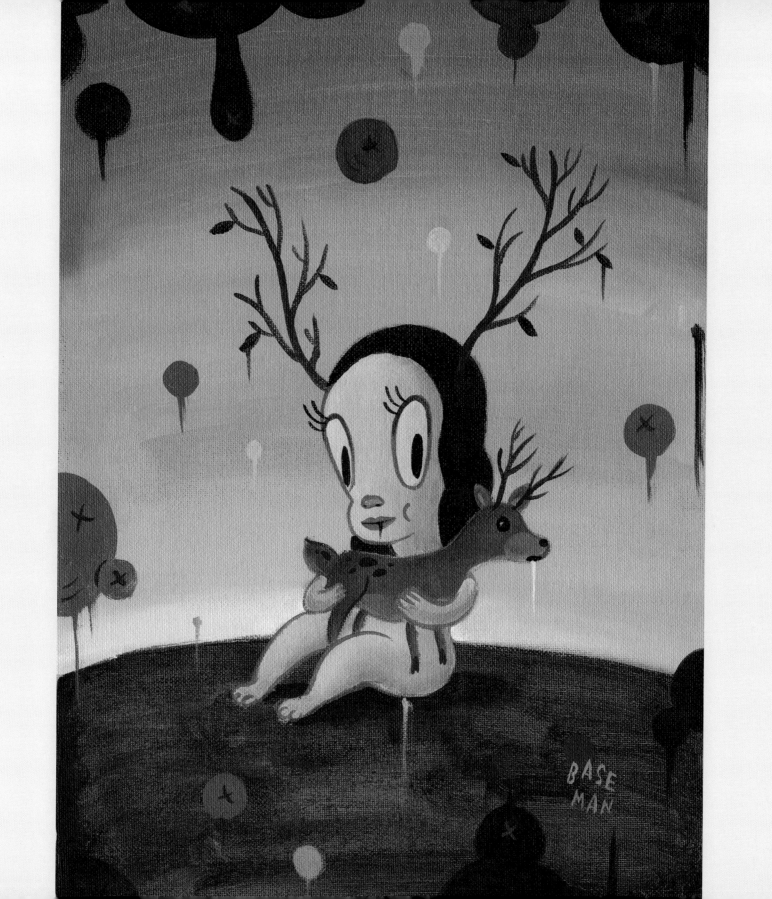

17. VENISON'S FEAST (WOLF)

DRAWING

12.625 X 9.5

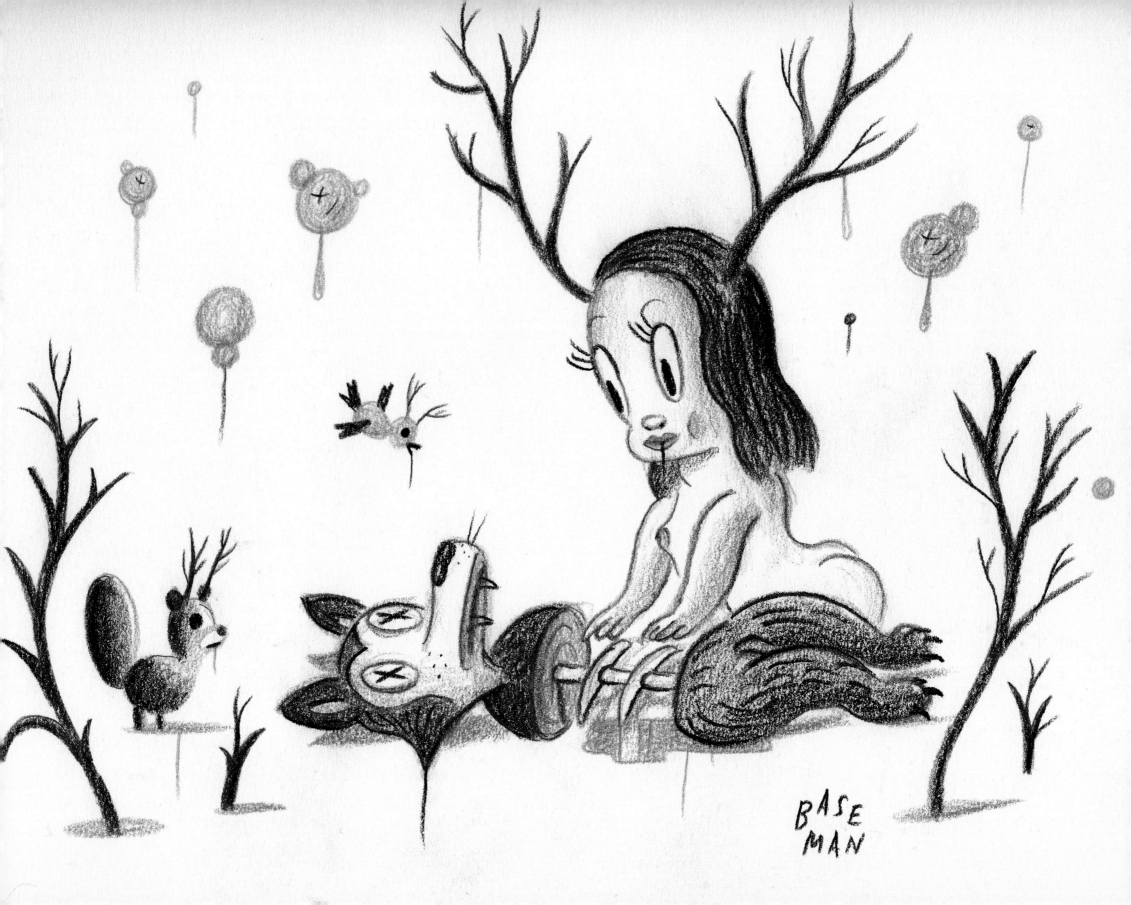

18. EGG WHITE WITH VENISON

DRAWING

5.75 X 9

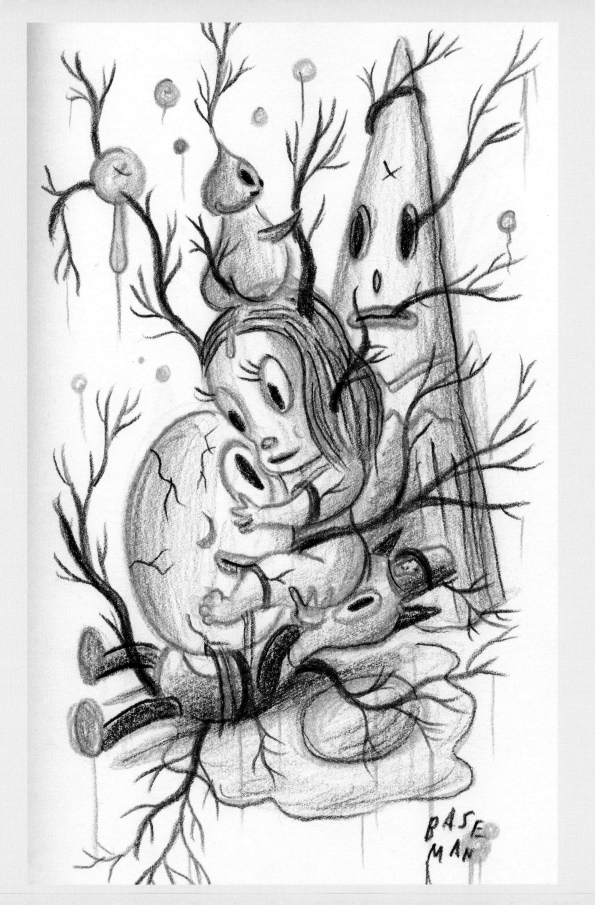

19. THREE VENISONS AND THE ONE THEY CALL TOBY

DRAWING

12.625 X 9.5

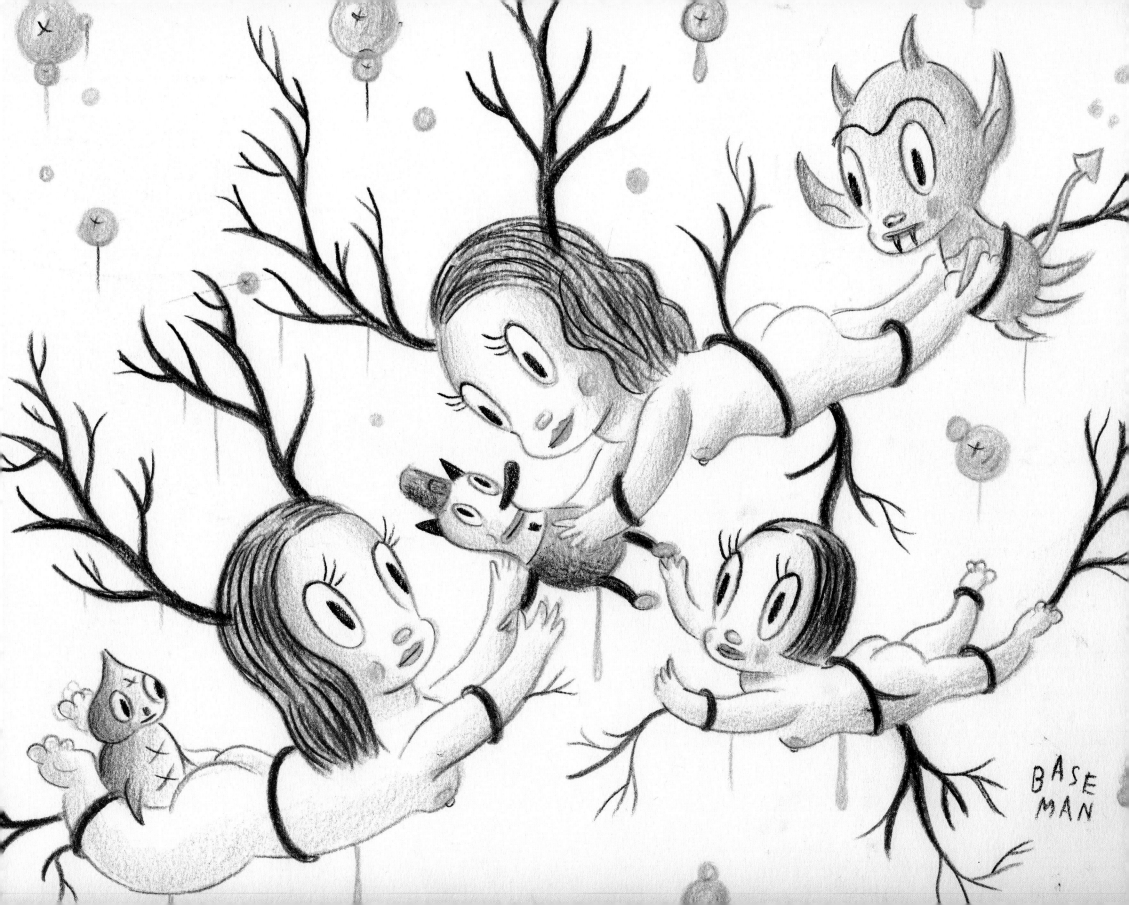

20. VENISON IN THE SKY

DRAWING
HAND-MADE BARCELONA PAPER
9 X 7

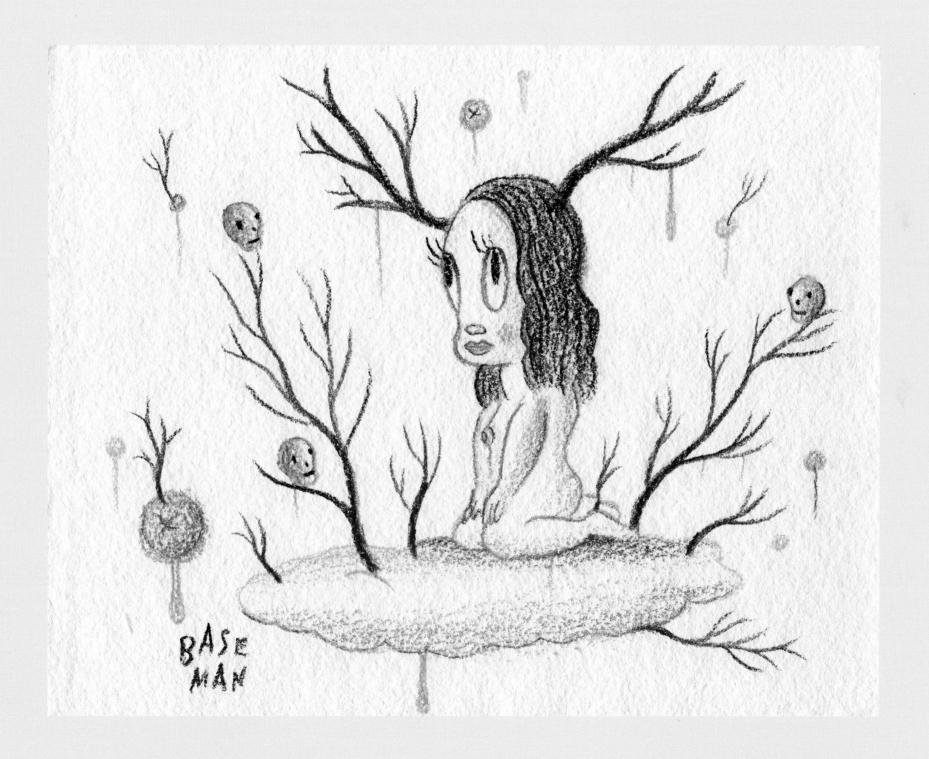

21. THE GIFT II

DRAWING
12.625 X 9.5

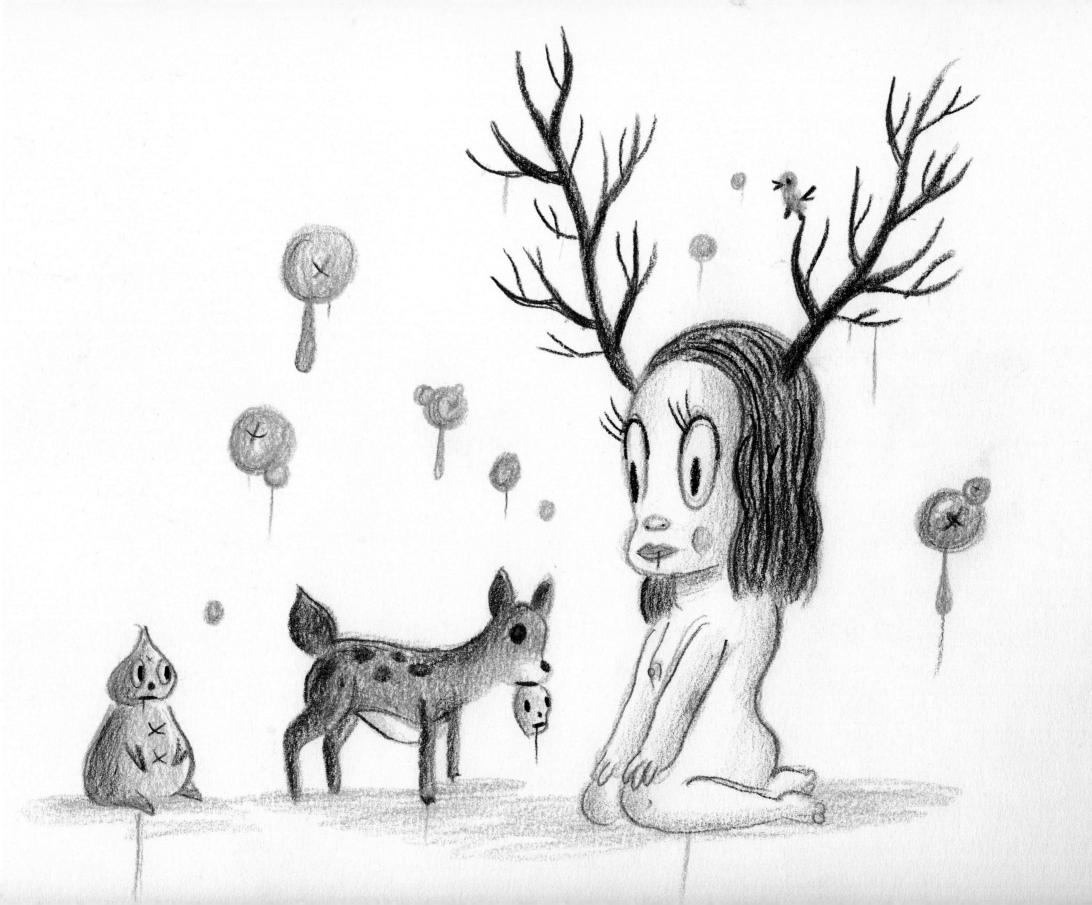

22. VENISON MEETING WITH THE DEVIL

DRAWING

12.625 X 9.5

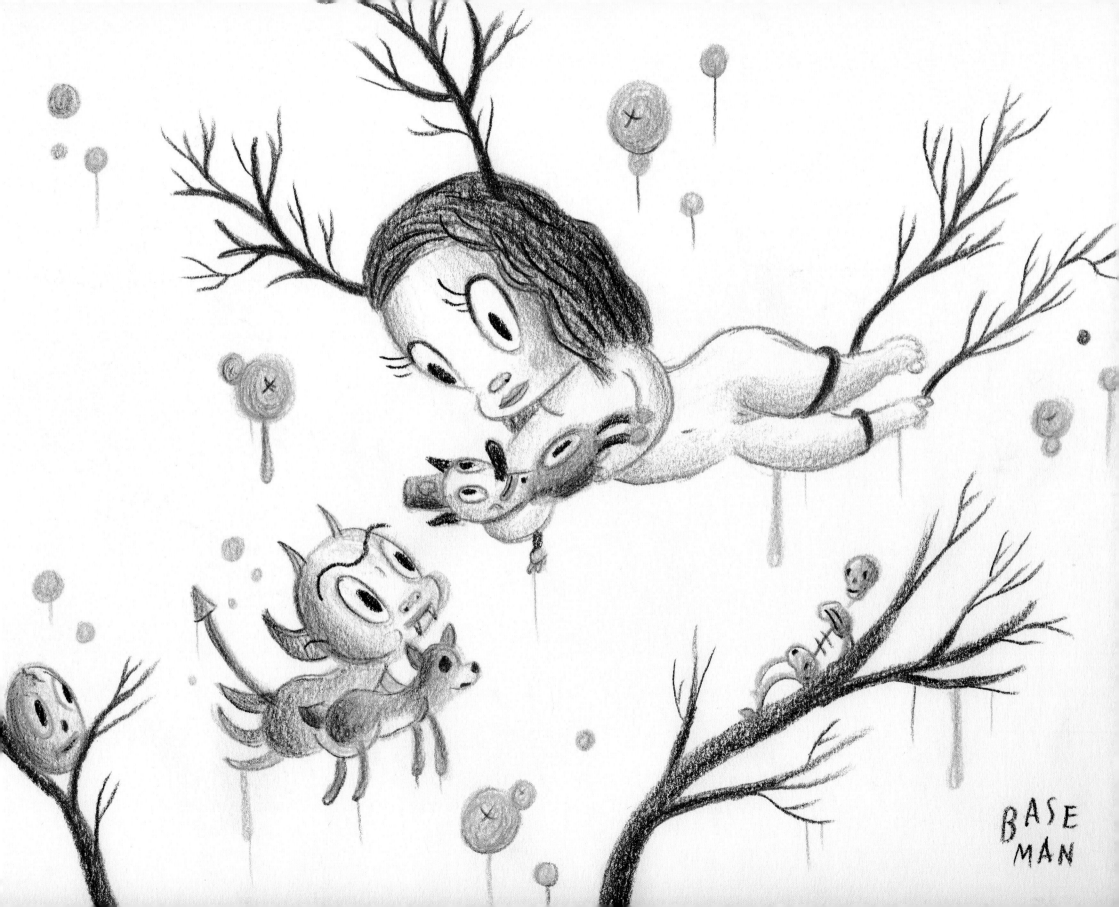

23. VENISON'S FEAST (VENISON)

DRAWING

12.625 X 9.5

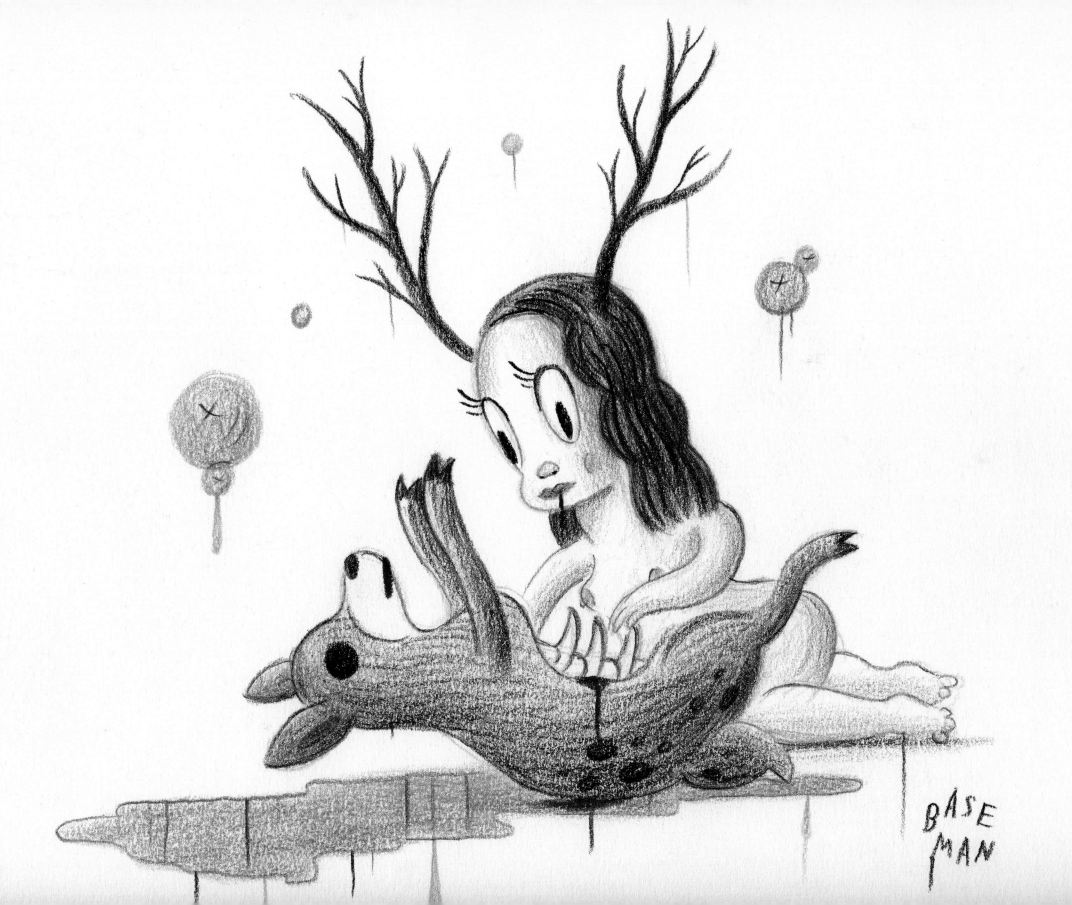

24. VENISON'S FEAST

ACRYLIC ON CANVAS
20 X 16

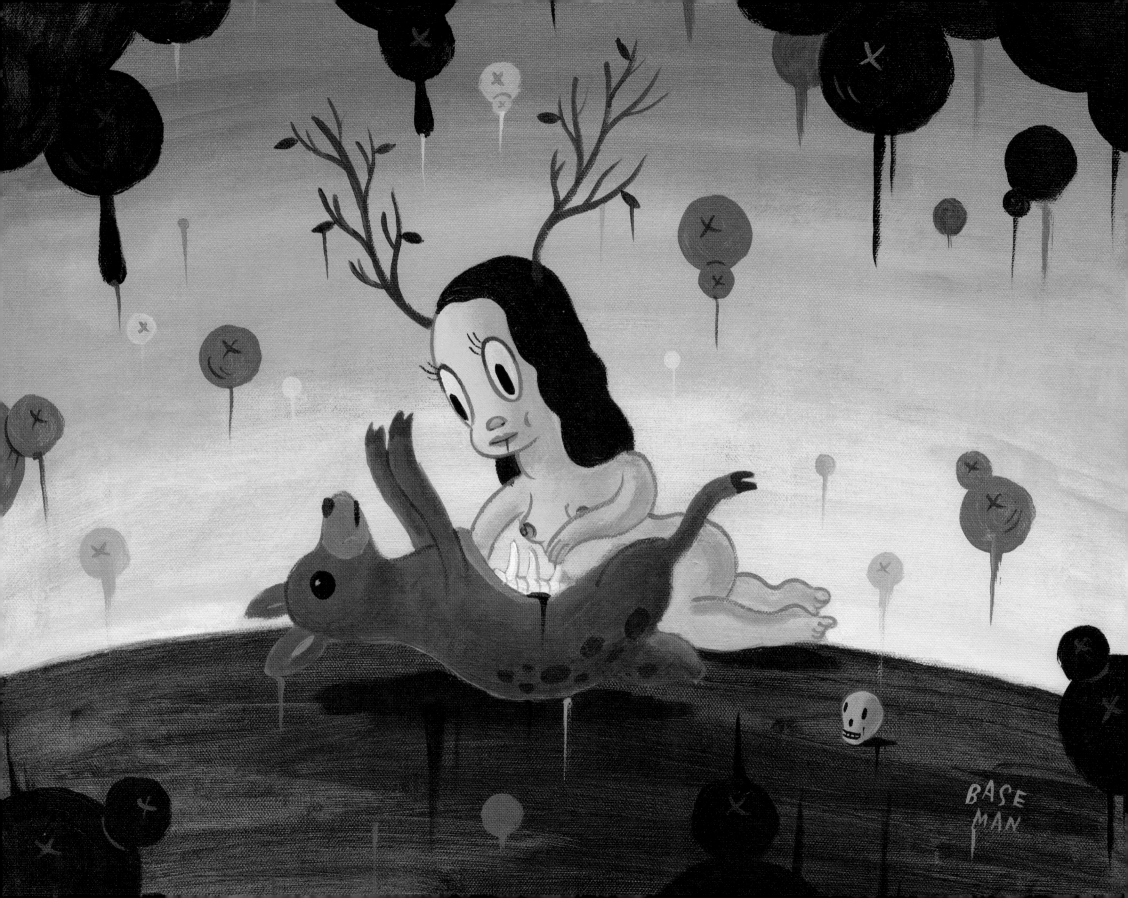

25. VENISON'S VERY SPECIAL FRIEND

DRAWING
HAND-MADE BARCELONA PAPER
9 X 7

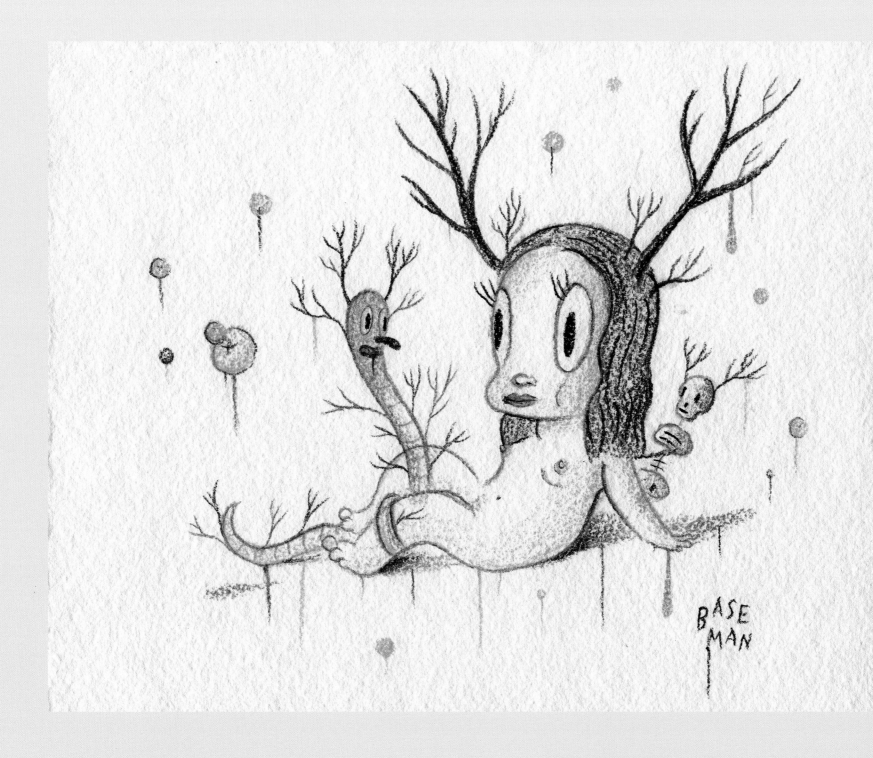

26. VENISON'S FALL

DRAWING
HAND-MADE BARCELONA PAPER
12 X 9.5

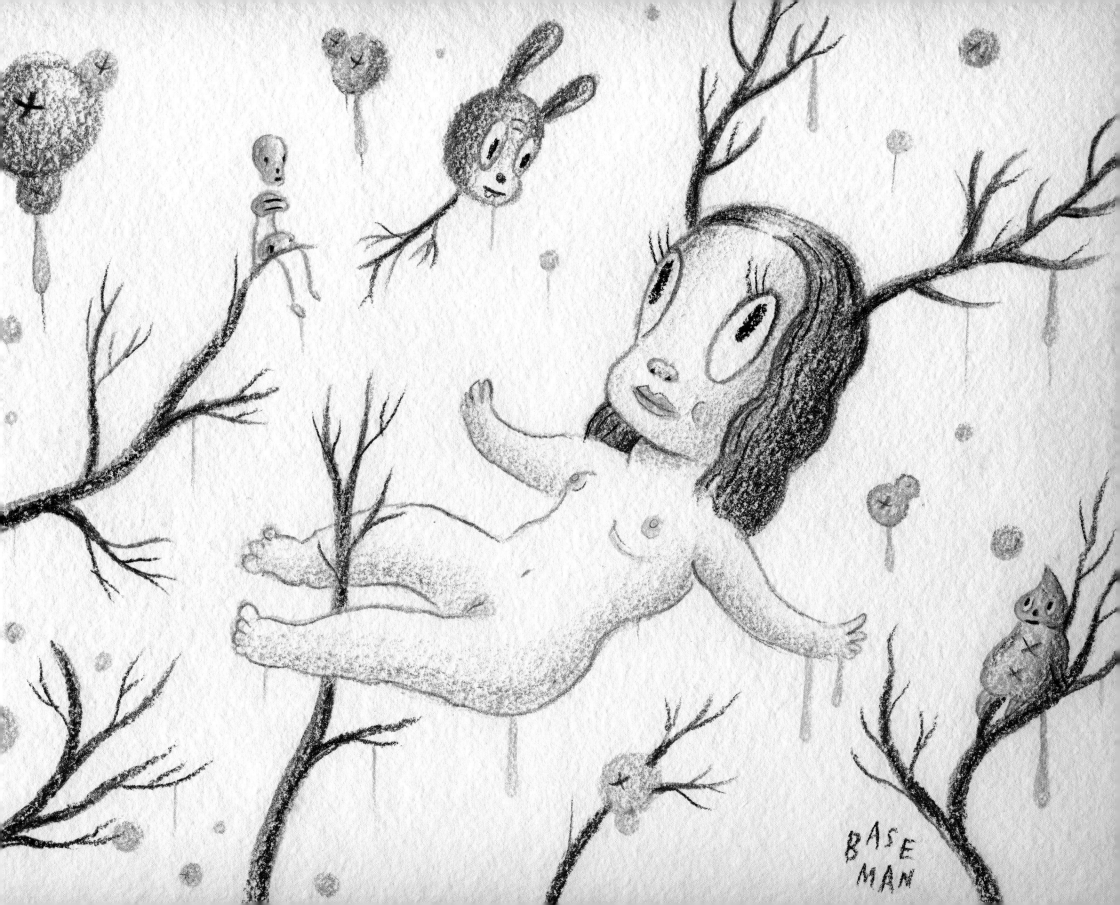

27. VENISON'S FATE

ACRYLIC ON CANVAS
20 X 16

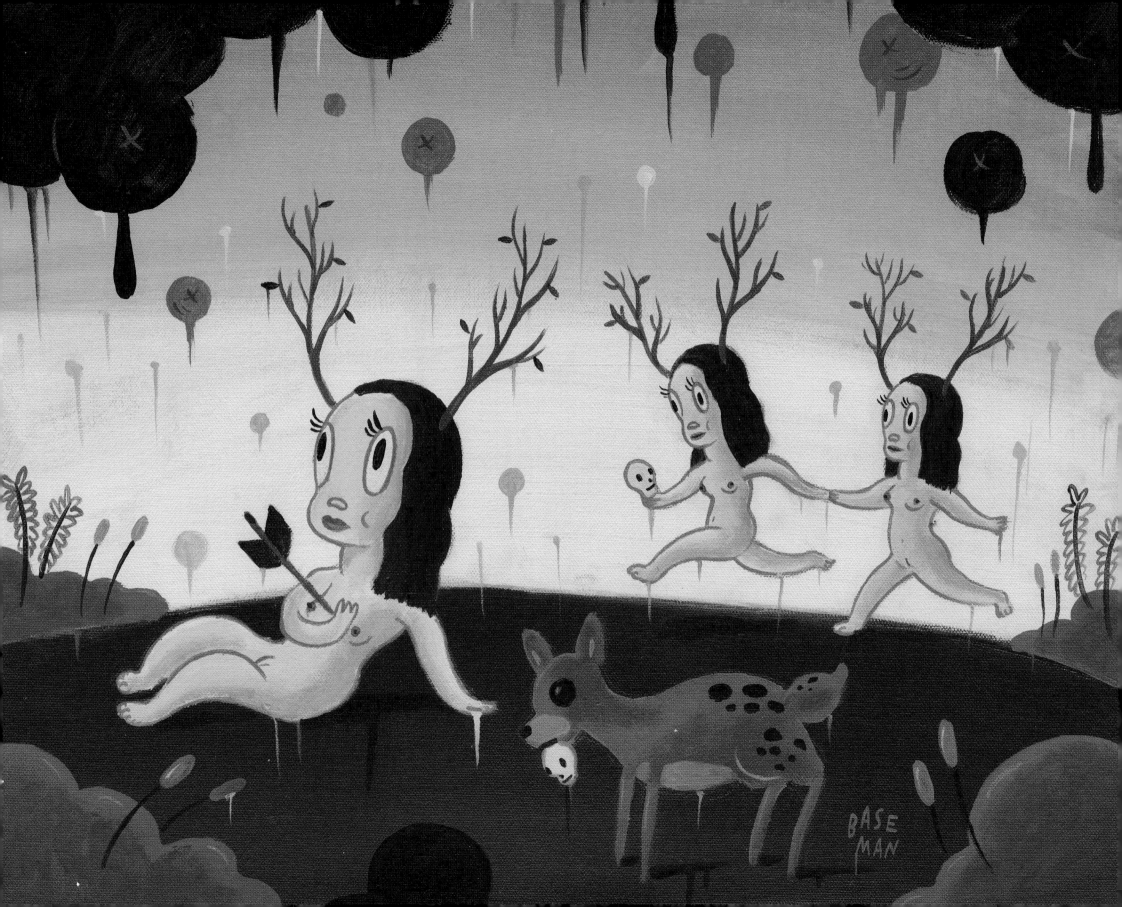

28. VENISON'S hopes and dreams

DRAWING

12.625 X 9.5

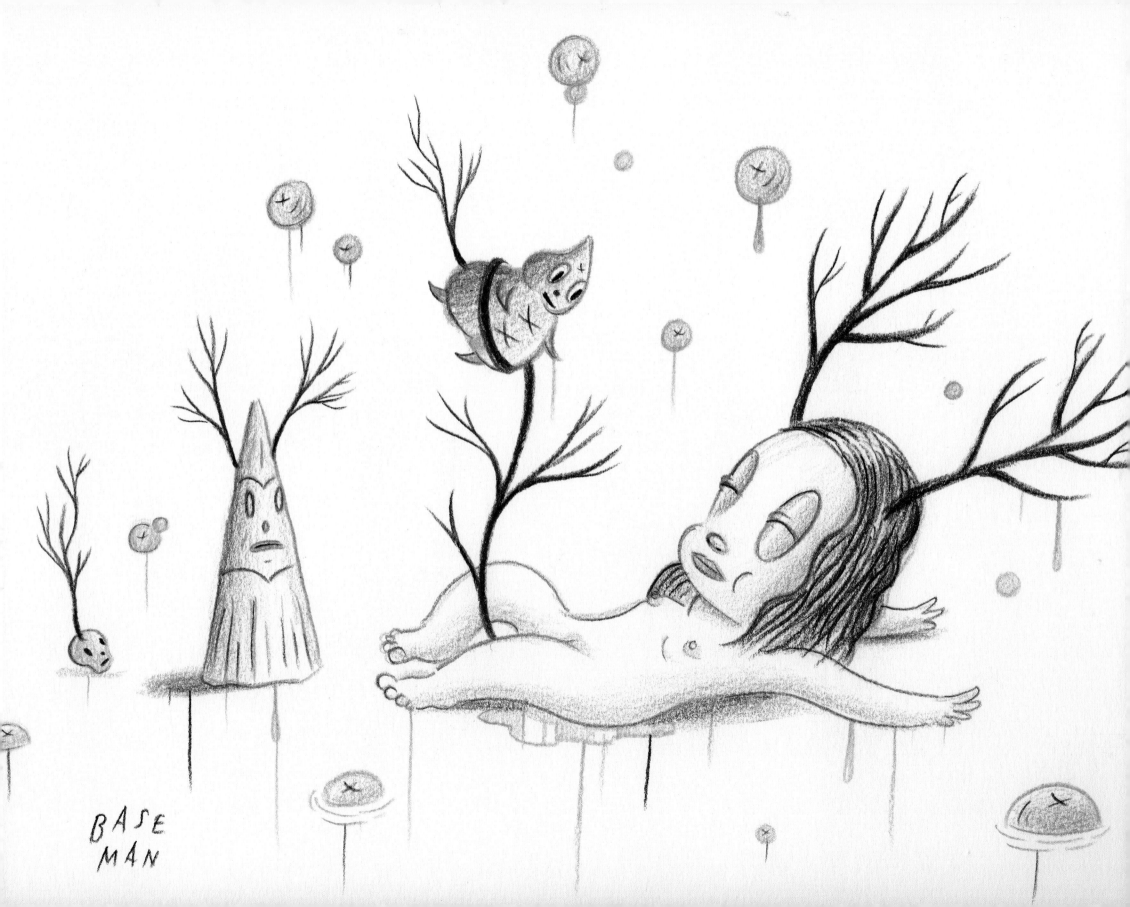

29. THE PRIZE OF VENISON

DRAWING
HAND-MADE BARCELONA PAPER
7 X 9

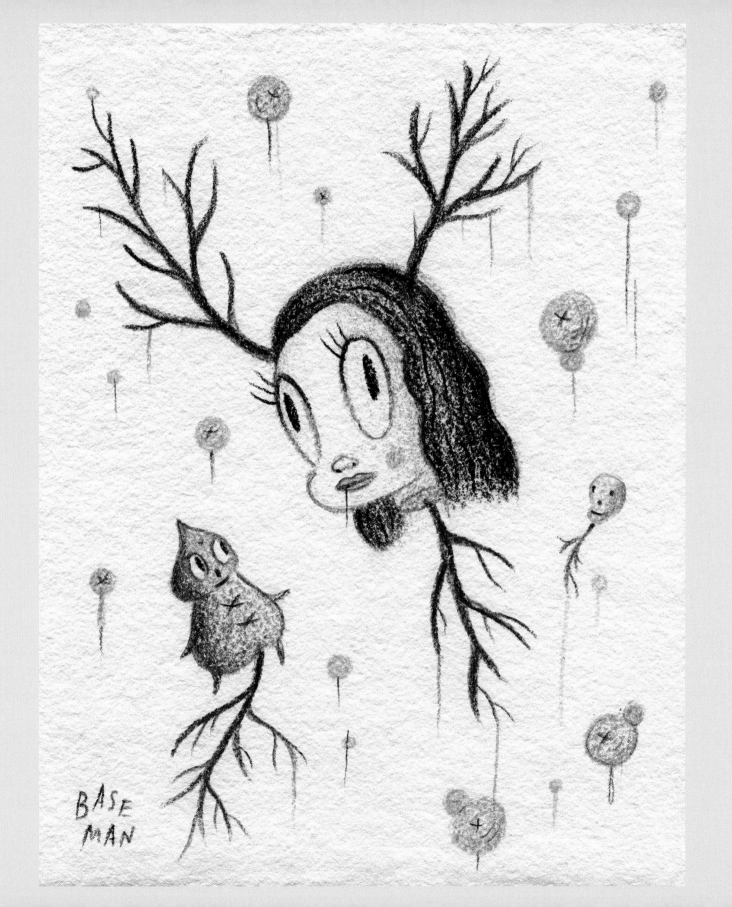

30. VENISON'S FATE

DRAWING ON CHINESE PRAYER BOOK
4 X 5.75

THE ACCOMPANYING BOOKLET IS AN ABRIDGED REPRODUCTION OF MR. BASEMAN'S PERSONAL SKETCHBOOK
IN WHICH HE BEGAN TO CHRONICLE HIS RELATIONSHIP WITH VENISON.

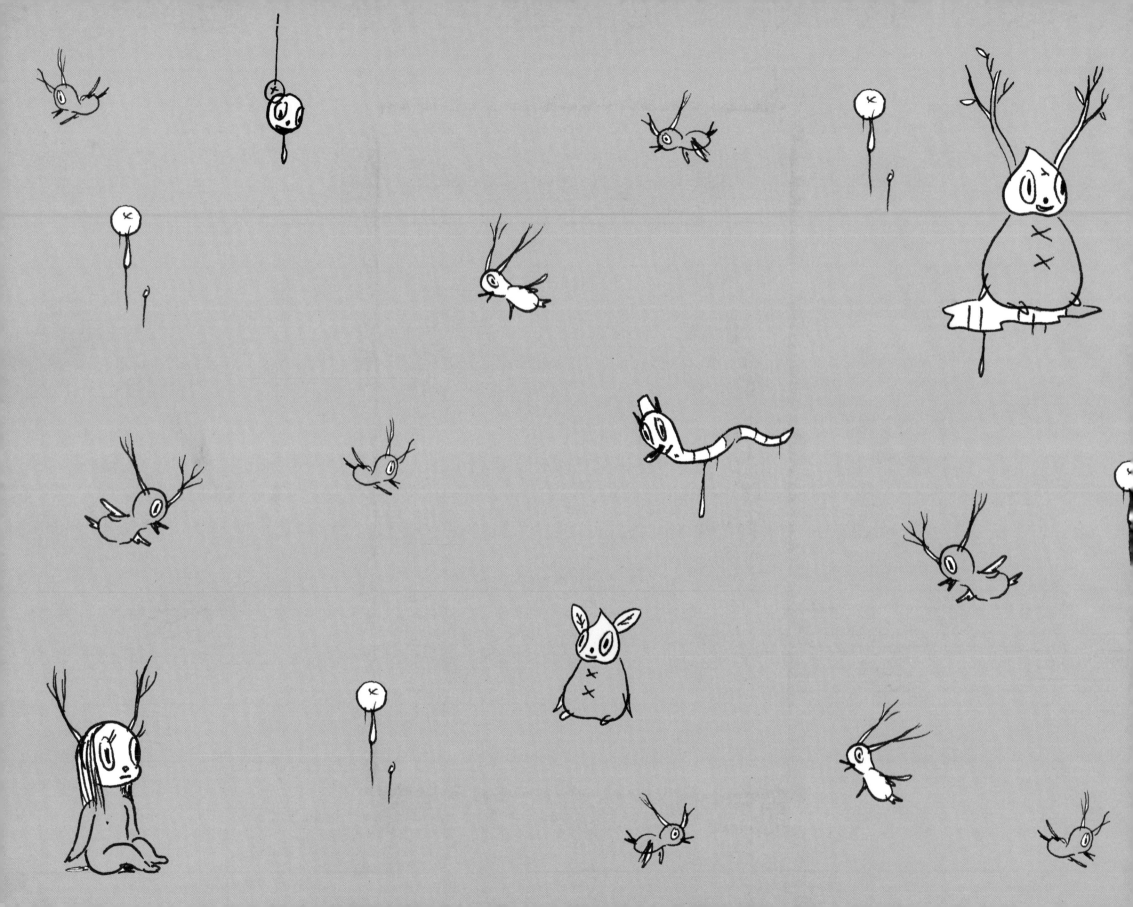